NORTHERN EXPOSURES

Rural Life in the North East

Chris Steele-Perkins

Published by Northumbria University Press
Trinity Building, Newcastle upon Tyne NE1 8ST

First Published 2007
© Chris Steele-Perkins

British Library Cataloguing in Publication Data.
A catalogue Record for this book is available from the British Library.

ISBN: 978-1-904794-20-2

Designed by Chris Steele-Perkins and University Graphics, Northumbria University
Printed by Graphicom srl, Viale dell'Industria 67, 36100 Vicenza, Italy

FOREWORD

I was brought up in the countryside in a small village on the north
Somerset coast. I took the freedoms of the country for granted. My friends
were farmer's children and it was a short walk from home to be in open fields.

All this changed when I went to Newcastle University and I became a
city dweller and later moved to London where I started working as a
photographer on urban themes: Inner City Poverty, Youth Subcultures,
London Life. I never lost my feel for the countryside, but it became a place
for holidays and weekend walks.

A long time back I started to think about doing a body of work on English
rural life, but it never happened; was never urgent enough. It was something I
always felt I could do later.

In 2002 I was asked by the Side Gallery in Newcastle if I would participate
in a project on the Durham Coalfields: the heart of the British coal industry
until all the mines were closed down under Margaret Thatcher's government.

The mining villages were dotted all over the area where coal was to be
found and were often not more than a set of houses around the road. Out of
the back garden you were in open county. I was struck by the way nearly
everybody had a relationship to animals, they all seemed to own a number:
horses, pigeons, dogs, ferrets, birds of prey and as farmers, sheep and cows.
This is where I started photographing rural life.

The work with Side ended, but I continued to work for three years in the
North East, mainly Durham, driving up when I could, sometimes for only two
or three days at a time, to photograph a bit more.

This was not the rural England I grew up in, of cider, soft rolling hills and
warmer weather, but in other significant ways it had much in common with
that England; an older, mainly Anglo-Saxon England. I wanted to document
these ways, and rituals of a life lived in the open, under the sky. This is what
these photographs are: a partial record, and a personal exploration, which
serves as both eulogy and elegy.

Chris Steele-Perkins

CONTENTS

INTRODUCTION

Imagine an exhibition hall full of people wearing Darth Vader virtual reality helmets. It doesn't need imagination though: this surreally incongruous image actually appears in Chris Steele-Perkins' book of photographs of Tokyo, *Tokyo Love Hello*. A shot of the audience at the Tokyo Motor Show, it illustrates the remarkable Japanese ability to accommodate the commonplace and bizarre in everyday life. He wasn't, he says in the preface, deliberately setting out to focus upon the bizarre; it just happened. He was "simply following a scent" to record "Tokyo, my Tokyo". At base the book is a kind of love letter to the city where he met his wife, Miyako. Still, he loves England too, and even though he has been involved in photo-reportage all over the world, from Africa to Afghanistan, in the background, as a kind of emotional base, there's always England.

There are different kinds of England, of course. Although born in Burma, he grew up in Somerset, the rural England of cider, balmy weather and "blue remembered hills". Travelling north to study psychology at Newcastle University he encountered a harsher climate, a more abrasive industrial society and an alien, though not unfriendly, culture. His psychology course didn't exactly fire his enthusiasm though, and he found greater satisfaction in becoming the photographer for *Courier*, the student newspaper, the first step on his journey to joining the Magnum team. His friends at the time, too, were the art students Sean Scully and Charles Hewlings, both of whom were subsequently to become eminent artists. He recalls with great affection an epic journey in the 70s in a camper van, a trip which was fraught with comic episodes.

After graduating he became photographer to what was then the University Theatre (now Northern Stage) taking publicity shots and making archival records. His first, typically vivid, solo exhibition was a study of the Hoppings, Newcastle's annual summer fair. In the familiar slogan of the *News of the World*, "all human life is there" and he captured it. Later, moving to London of necessity (that's where the photographic commissions were) he focused upon urban themes of inner city poverty and youth sub-cultures. By this time he had almost lost contact with the countryside but in 2002 he was invited by Newcastle's Side Gallery to participate in a project on the Durham Coalfields which used to be the heartland of the British coal industry.

From a familiarity with a comfortable rural society he had now entered the world of "Billy Elliot". The Durham pit villages, as in other mining areas, exist cheek by jowl with the countryside and as D.H. Lawrence observed in Nottingham and the Mining Country, the miner's life was "a curious cross between industrialism and the old agricultural England of Shakespeare and Milton". Lawrence, who, interestingly,

was born in Scargill Street, Eastwood, described how his father, setting off at five in the morning for the fore shift at Brinsley Pit would "hunt for mushrooms in the long grass, or perhaps pick up a skulking rabbit". Much has changed in the 78 years since Lawrence wrote that essay: the mines have gone for a start; but old habits die hard. Around the former pit villages, men (it's nearly always men) still rear pigeons, hunt with ferrets, race whippets, keep birds of prey, or grow leeks. Lawrence maintained that this owed to an undisclosed love of beauty that was often derided in the brutalised world of industrialised life. *Billy Elliot* deals with this, as does Barry Hines in *Kes*. In a marvellous set piece in the novel, the half starved, victimised loser Billy Casper, encouraged by his humane English teacher, suddenly becomes articulate and in an excited outpouring describes in detail how to train a kestrel. The same expertise and arcane language typifies those enthusiasts who go lamping for rabbits or grouse shooting. Contrary to tabloid class stereotypes there's a camaraderie amongst countrymen whether they are shooting grouse on, say, the Raby estate, or ferreting on the outskirts of Sunderland. Furthermore, although this project began with Haswell Plough Mart, a source of riches second only to Samarkand according to local lore, it extended outwards to farmlands stocked with horses, sheep and cows.

These inter-connected rural cultures are recorded impartially in the original spirit of Mass Observation. There is no evident indignation or bitterness about the scourge of foot and mouth disease or of the criminalisation of hunting. Nor is there sentimental leniency shown to teenage delinquents in the making, the underage drinkers acting daft for the camera at Horden, for example. There's another memorable image from Haswell, of a daredevil caught in mid-air as he's flung from a mechanical cow. This rural cowboy reminded me powerfully of a shop window I once saw in Ely. One half of it was stocked with saddles, bridles and Barbour jackets; the other half contained stetsons, fringed shirts and rodeo gear. Nowadays there truly are interconnected rural cultures but some of them, of course, are determined by the inner fantasies of their participants. Maybe the paramilitary camouflage worn by the lampers who pose behind their bag of twenty rabbits is a reflection of theirs. This shot was evidently taken at night and the lampers' guarded expressions and the enveloping gloom give it a haunted, and haunting, atmosphere. Another atmospheric image is of the close-up of the boy with a polecat. In the contrast between smooth moon face and hairy animal we find absolute proof that Tokyo has no monopoly of the everyday surreal. An inescapable feature of this strange apparition (which could easily be a still from Fritz Lang's *Metropolis*) is the tenderness with which the polecat is

being held. That tenderness, indeed a general sensitivity to animal husbandry, is recurrent throughout this survey, whether it is the gentleness of pigeon fanciers, the "walking" of beagle puppies, the careful shoeing of horses, or, for that matter, the boy who, like Billy Casper, proudly shows off his pet owl. Nor is Steele-Perkins squeamish about the elemental realities of country life, the messiness of lambing, for instance, or the sight of slaughter houses awash with blood: the countryside, as he points out, "is a business, not a natural idyll".

I notice that often I've called his photographs "shots". This is perhaps a misnomer because it suggests someone transient who grabs the moment and then moves on. Nor does "embedded", the current jargon word for photographers temporarily located, suffice. Neither term fairly describes the way in which, irrespective of commissions or projects, he returns to the North East and its countryside again and again. He simply likes it and its people. D.H. Lawrence would hardly recognise the post-industrial working class with its predilection for designer labels, mobile phones and all the other trappings of consumerism. Doubtless he would be dismayed by their increasing indifference to the countryside. Chris Steele-Perkins is less judgemental: his attitude is one of affection, not condescension. Still, he's not blind to modern degradation, his eloquent image of the Dishwasher dumped on the Pennines effortlessly exposes the same malign sensibility that led to the killing of Billy Casper's kestrel.

And he also recognises that this shared rural culture is slowly dying. In these photographs, however, he affectionately documents what survives, using his psychological nous to hint at the inner workings of his subjects' minds. Allied to his shrewdness in documenting cultural mixes and overlaps is his enviable skill in recording the landscape too.

Did I mention his sense of humour? It's always there in the background delighting in absurdities and idiosyncrasies such as the image of a fox, which is actually a mere mascot on the bonnet of a car, appearing to race across the landscape or the ceremonial gravity of the bidders at the Haswell Plough Mart auction as they compete to buy a second-hand door.

Po-faced commentators would, I suppose, designate this survey as an essay in cultural anthropology. It's not really that, though. Like his suite of Tokyo photographs it's more of a love letter to a region and a way of life for which he feels deep undying affection – for all its faults.

William Varley
2007

Who won this land and carved it?
Loved it, cursed it, marked it?
Who's reached the end of the safe and the known?
Whose powers do we fear to harm it?
We cared for the fell. The fell kept us.
Now they're paying us not to farm it.

And the wind bowls out of the darkness,
And it sings of change and sameness;
From Cawfield Rig to Sewingshields Crag
It can find no rest, no stillness,

For the laws of the dark are the ways of the heart,
Of the crow, of the claws on the fox and the hawk –
It's the line of the tide in the sand we're writing –
It's the slant of the land, it's the slope of the age,
It's the rain and the cold and the wind we're fighting.

Extract from *This Far and No Further*, Katrina Porteous

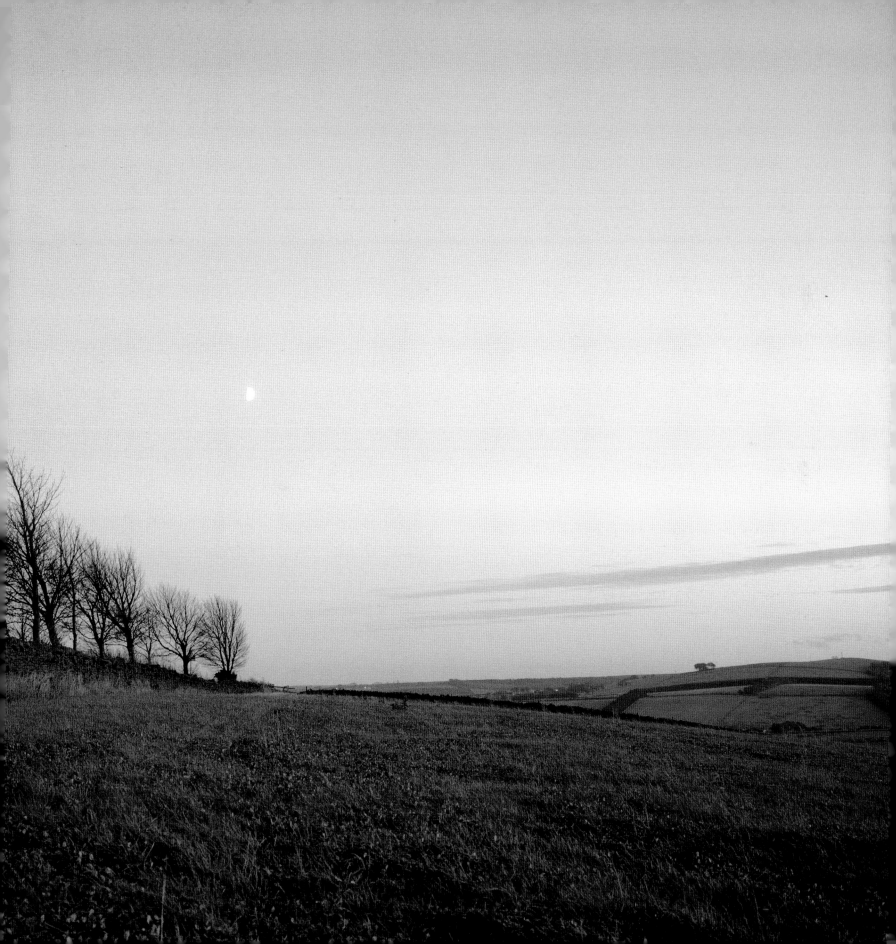

HUNTING WITH HORSE AND HOUND

I was told, by what I consider a reliable source, that there are more horses
in County Durham than in the whole of Ireland. On the face of it this seems
unlikely given the Irish love of horses, but I quickly realised that the love
of horses in this region is no less passionate.

Hunting foxes with horses and hounds was a centuries old pursuit across
the country and a necessary one, in as much as foxes prey on small farm
animals such as chicken and lambs. The debate, in Parliament, as to whether
this form of hunting was suitable in the modern world was lost on the grounds
that it inflicted unacceptable cruelty on the fox. The fox will now be shot, in all
probability injured first, and suffer accordingly. When the pack dispatched the
fox it was ended in seconds, with certainty.

There was also something of the strange atmosphere of class war involved
in this legislation, the hunters being seen as toffs and snobs who deserved what
they got in the form of a legislative kicking.

Most of the work I did was with the South Durham Hunt who were far
from this stereotype. They were a collection of local farmers, small business
people and various others. Normal enough people.

South Durham Hunt. Car mascot

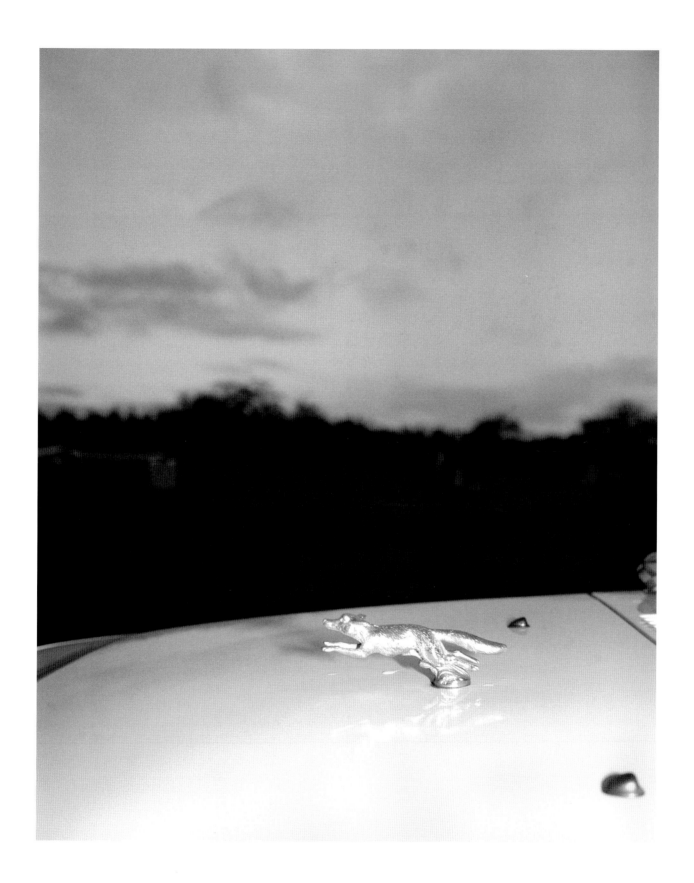

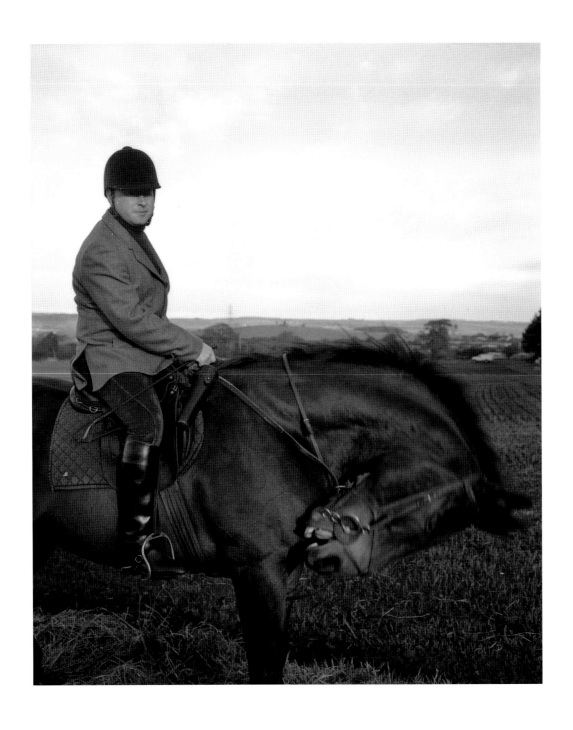

South Durham Hunt

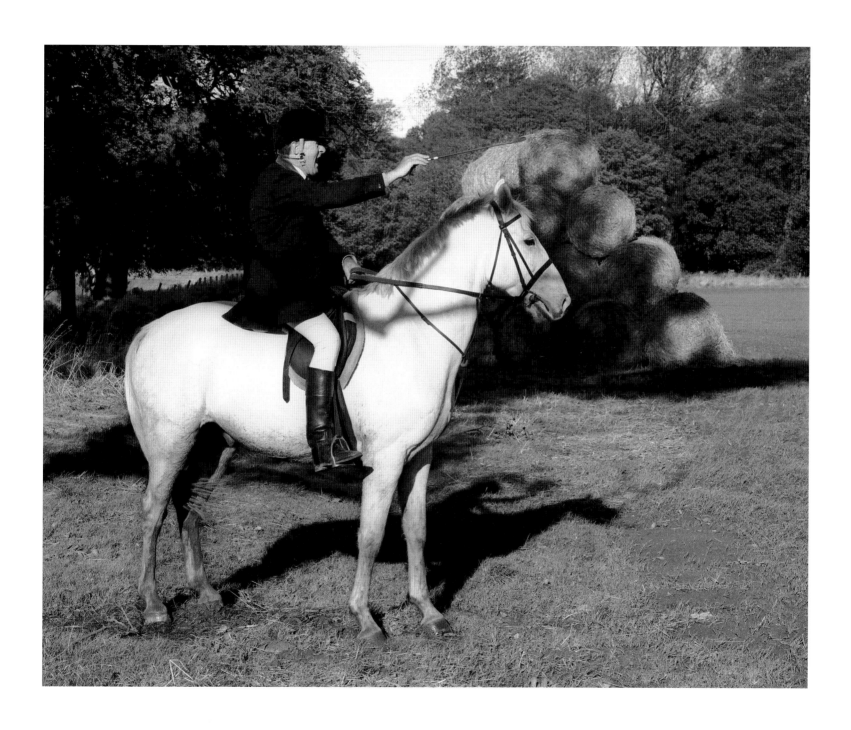

South Durham Hunt. Sighting the fox

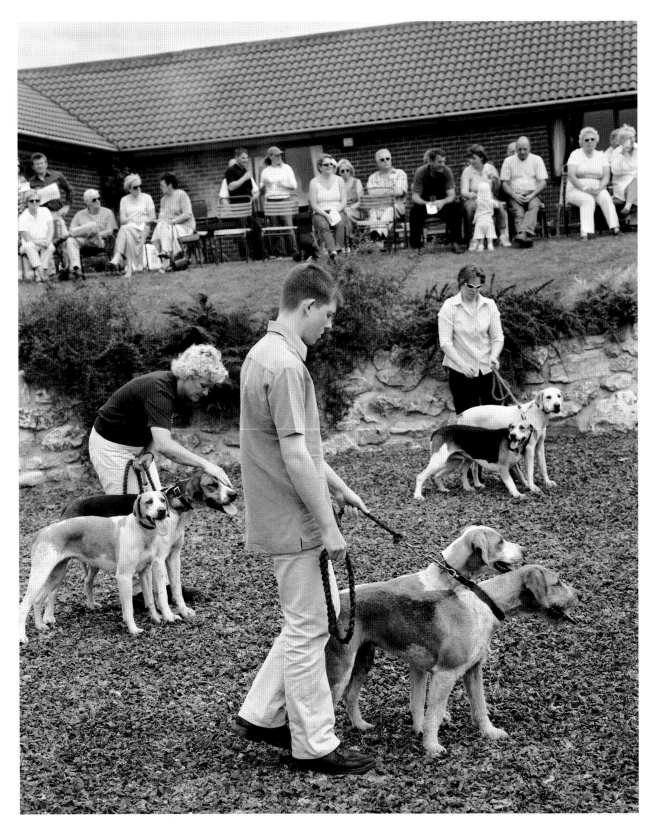

6 South Durham Hunt. Puppy Walk where hounds are trained in tandem with an older dog

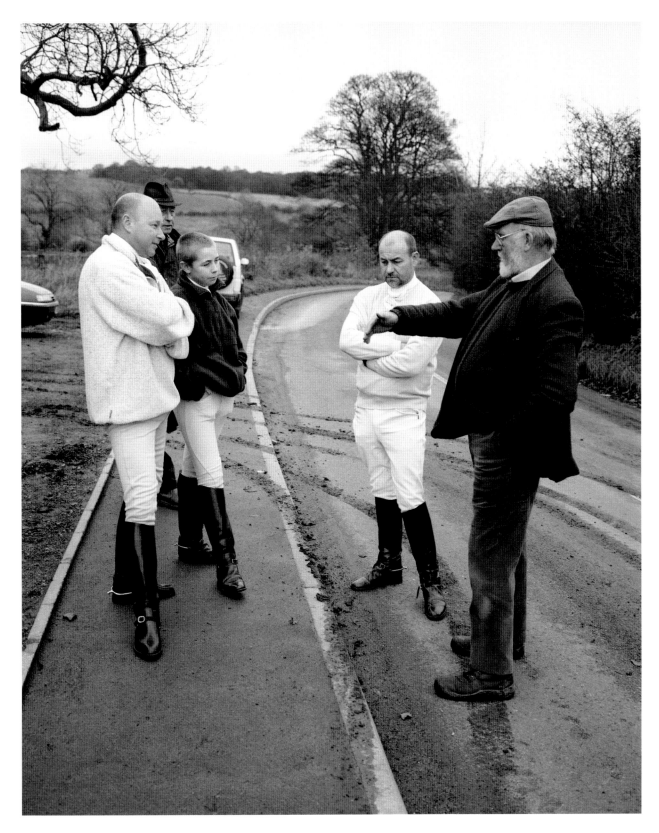

South Durham Hunt. Waiting for the start

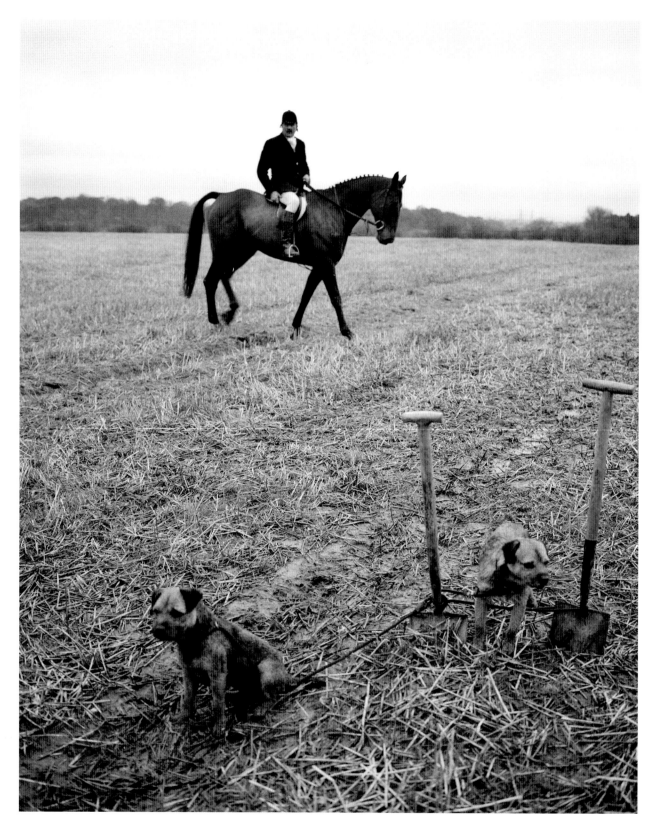

South Durham Hunt. Master of the hunt, Mark Shotton

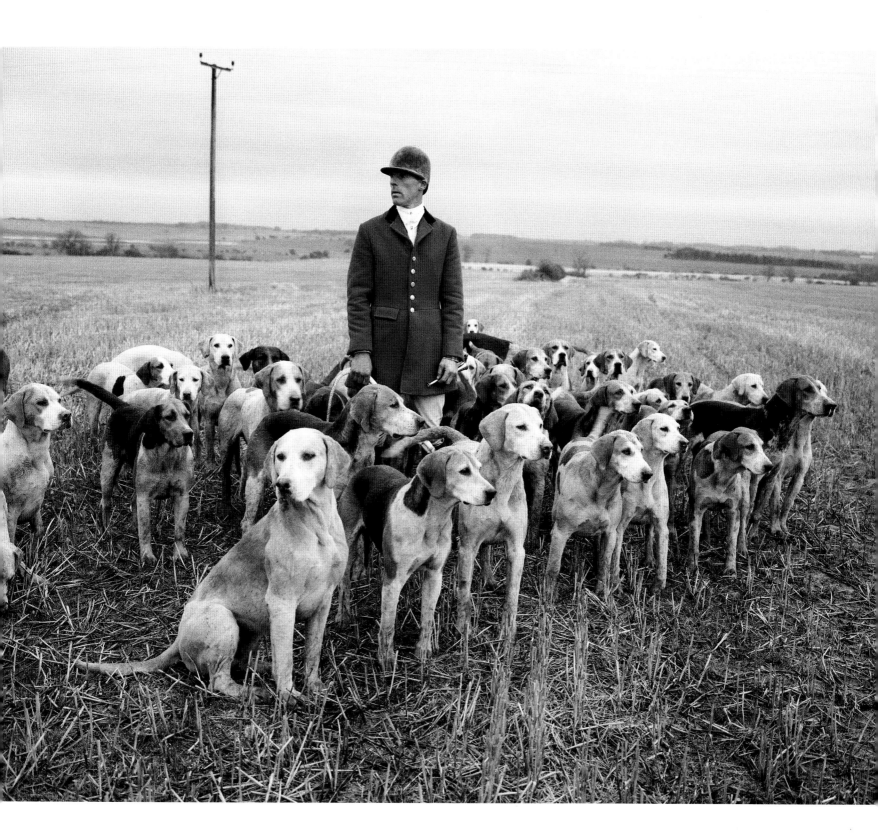

South Durham Hunt. Huntsman Simon Dobinson

9

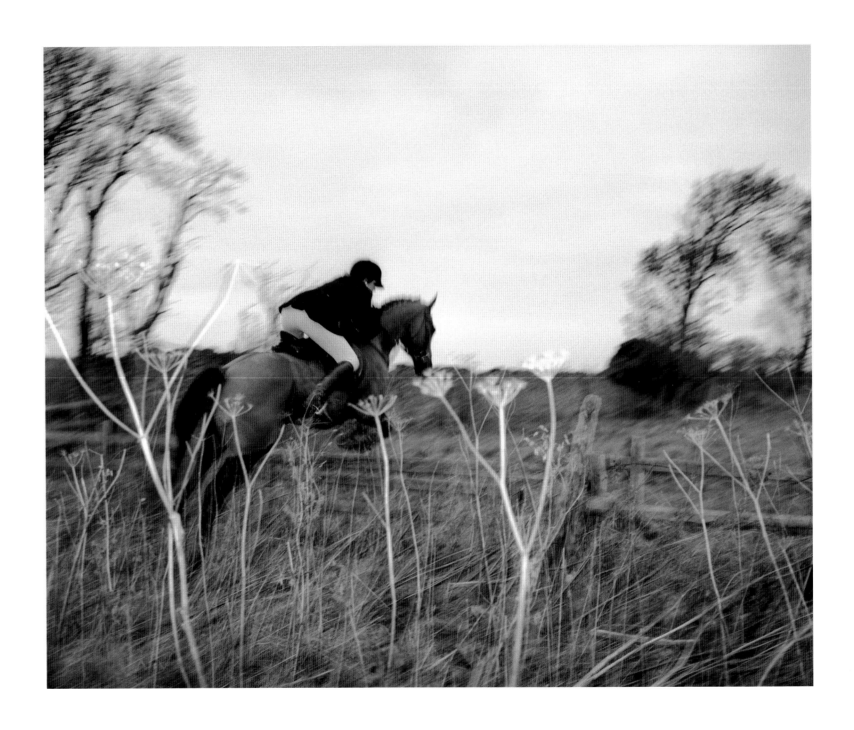

Zetland Hunt. Chasing the fox

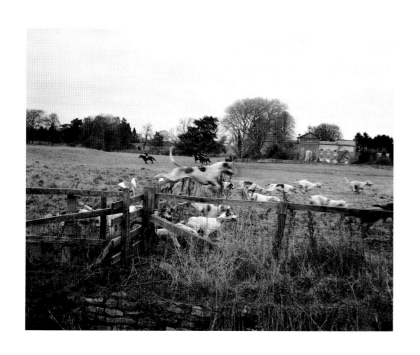

BIRDS

Birds of all kinds are kept as pets, and some game-birds kept for hunting
and display, but it is pigeons that are wedded to the image of British working
class culture and as that traditional working class disappears, so it seems do
the pigeons. Bowburn Pigeon Club has very few younger members. The
enthusiasm, however, of the older members and their competitive spirit remains
strong. There is a magic in a pigeon's flight, sometimes hundreds of miles, from
an unknown location back to the home loft. The secret rituals of preparation,
feeding and mating which their owners develop so their birds fly home faster
than their rivals, remain compelling, but not always to the Nintendo generation.

Bowburn Pigeon Club. Craig Prince and his son

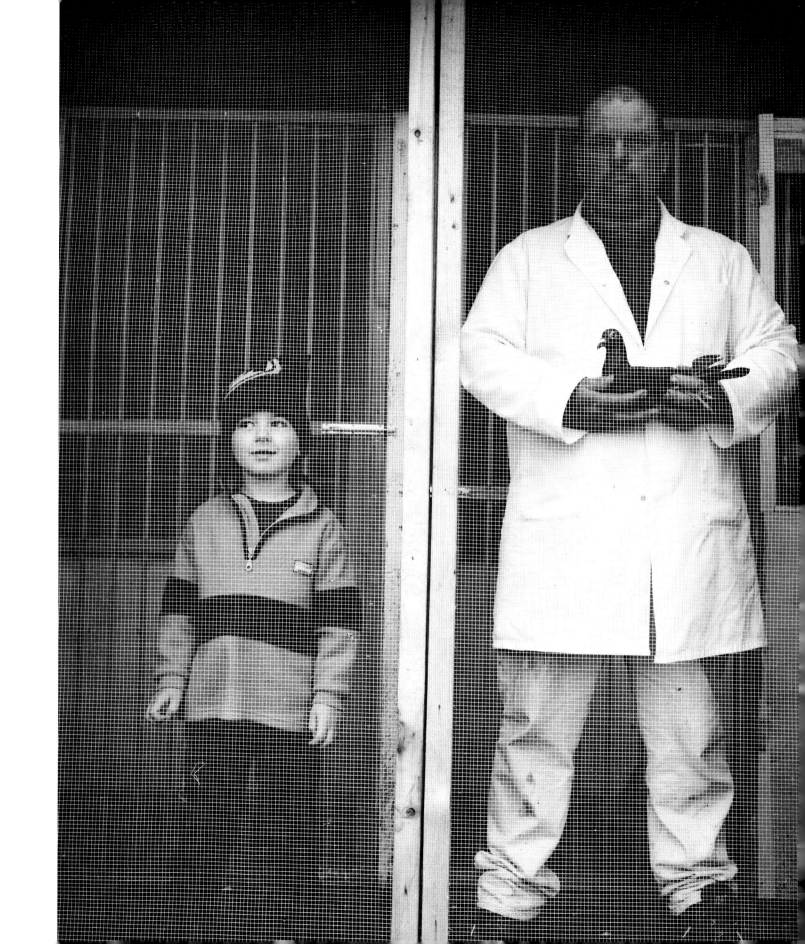

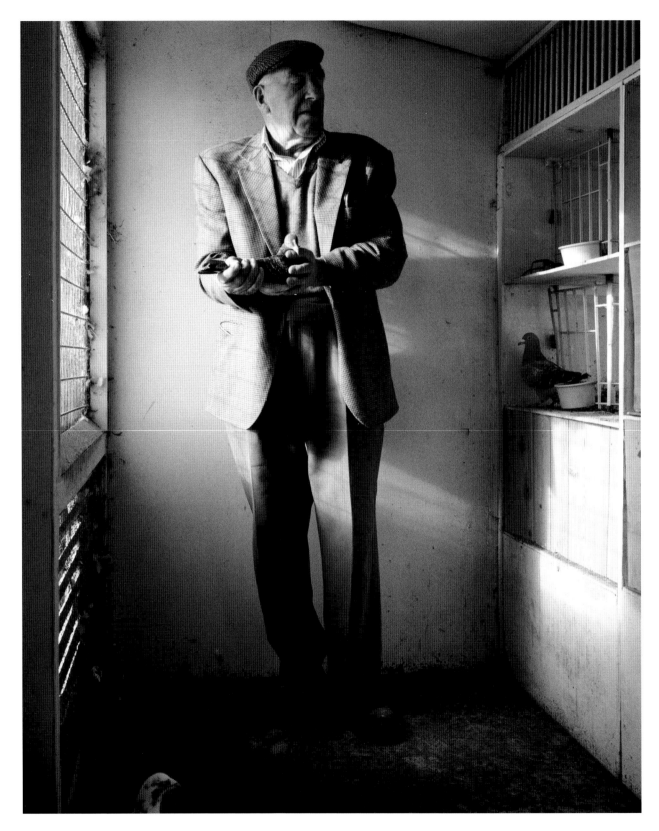

Bowburn Pigeon Club President, Jack Allison

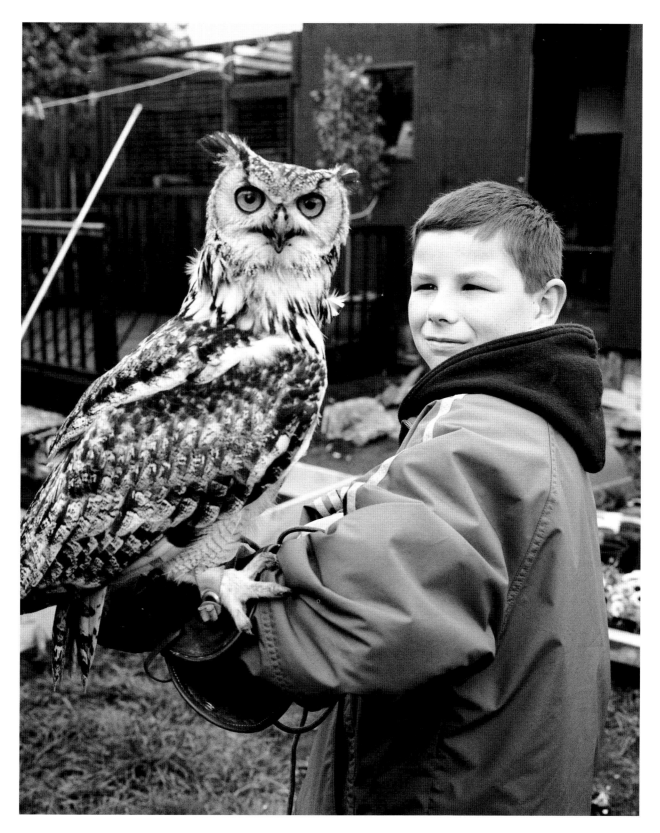

Pet owl

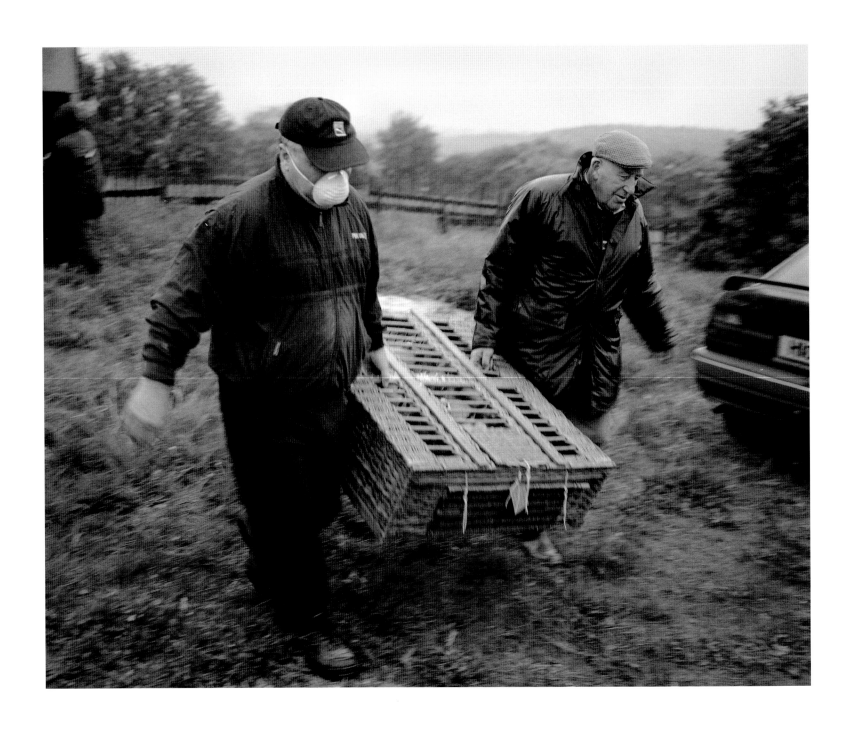

Bowburn Pigeon Club. Pigeons ready for transporting to the start of race

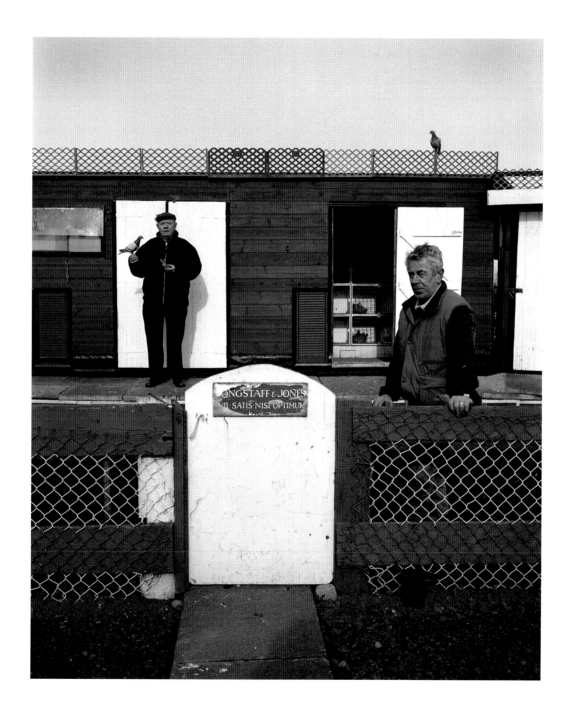

Pigeon loft at Easington

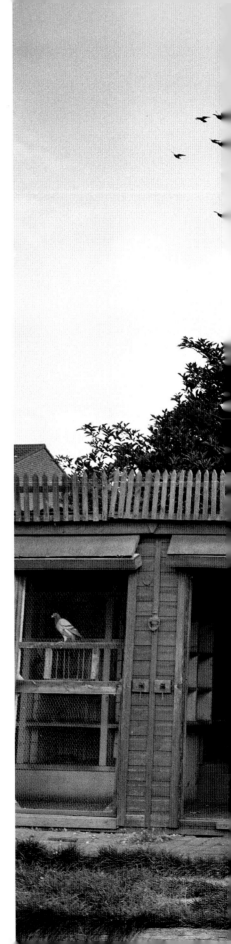

Bowburn Pigeon Club. Club Secretary, Jackie Johnson, waiting for his birds to return

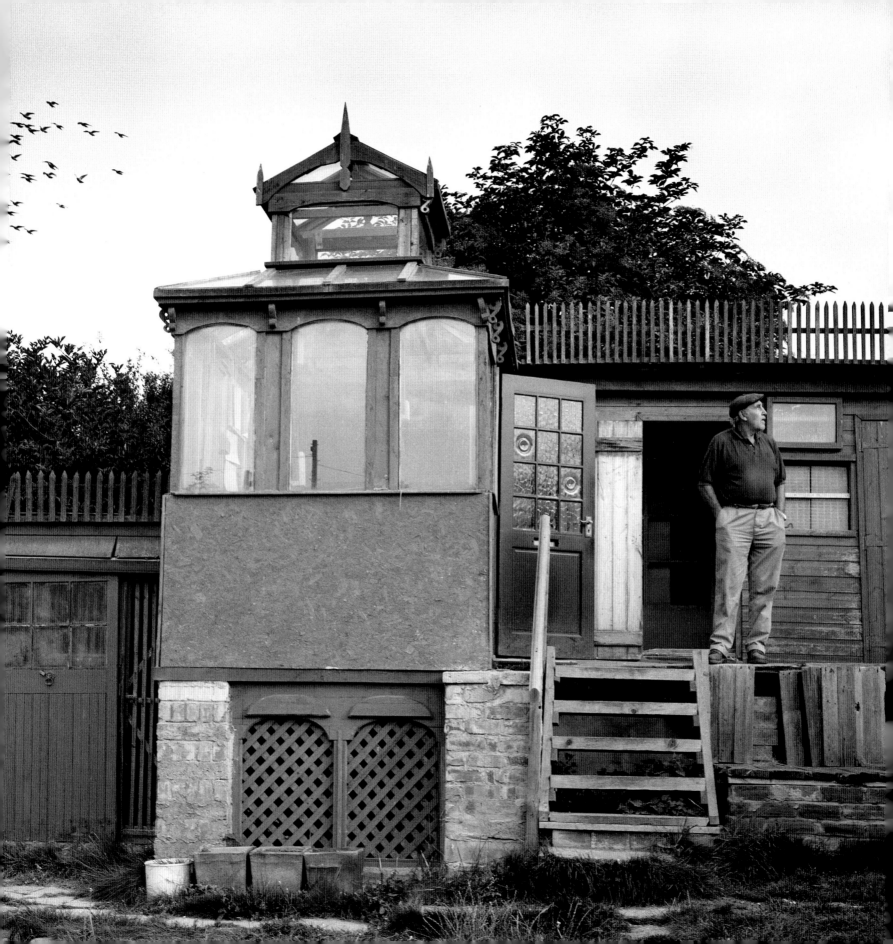

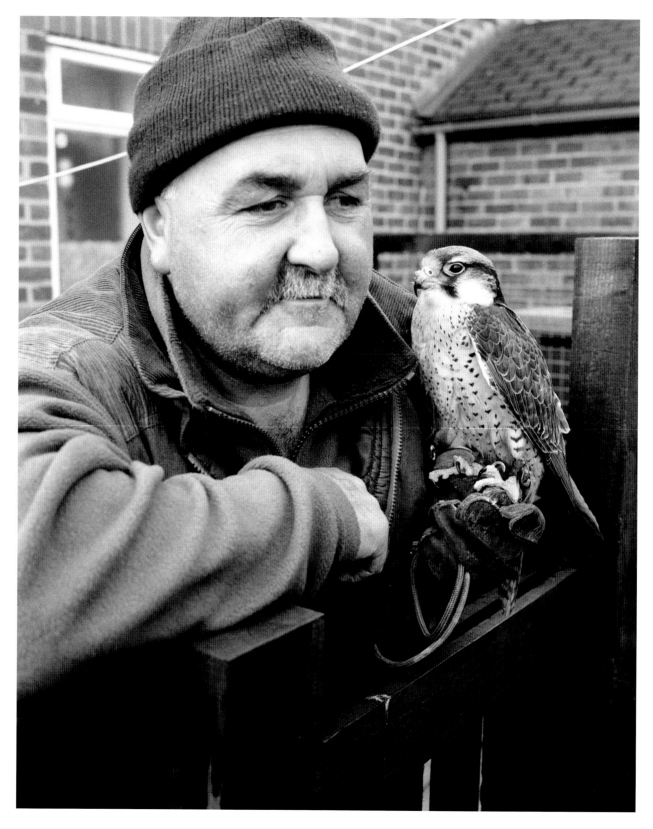

"Masher" with falcon

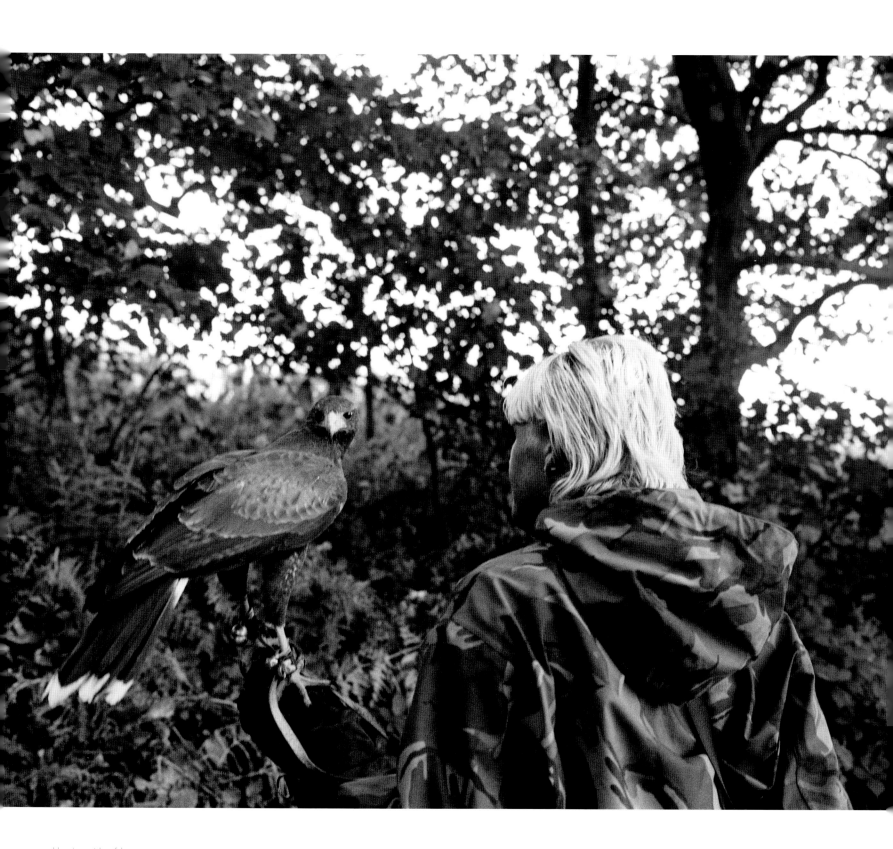

Hunting with a falcon

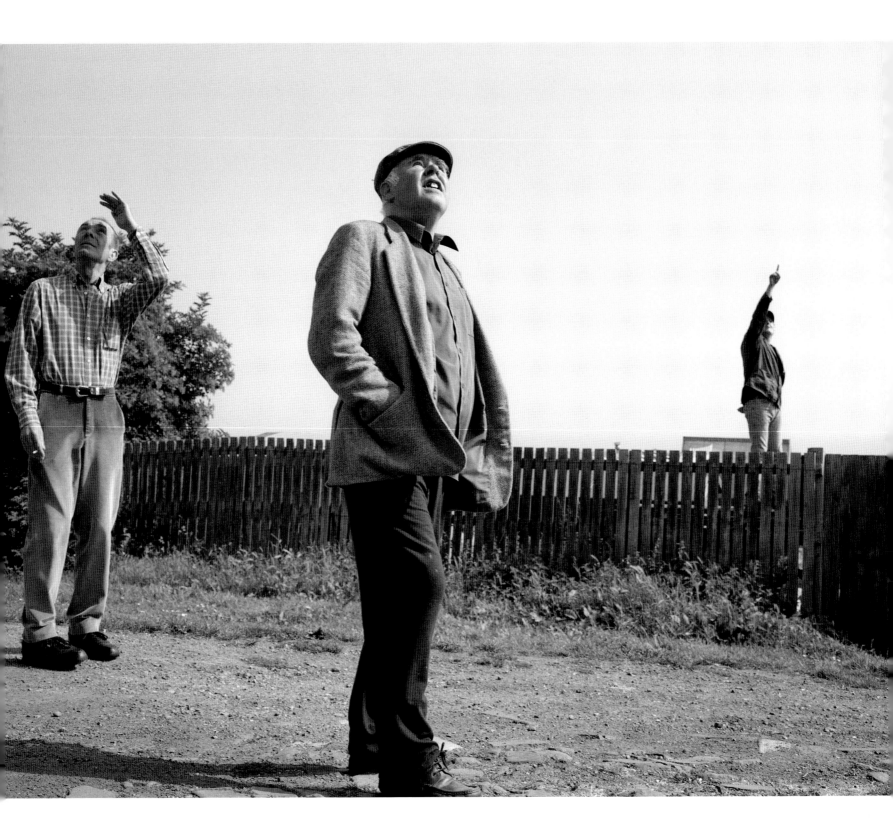

Horden, waiting for pigeons to return

FERRETS/POLECATS

Ferrets are not wild animals, they cannot survive in the wild, unlike their close relative, the polecat. It is not easy to distinguish the two by looks, but the polecat is more muscular, usually darker and can bite you much harder.

Hunting with either of these animals is known as ferreting. There are basically two forms of ferreting: either the exits of a rabbit warren are netted and a ferret introduced down one hole, driving the rabbits into the nets; or the holes are left open and dogs, usually lurchers, are used to chase the rabbits once they come out. The problem for the ferret owner can be that the ferret catches a rabbit in the warren, has a meal and goes to sleep. It can be a long wait for it to emerge. Radio locators are sometimes used so that the sleeping ferret can be dug out with a spade instead of waiting for hours for it to wake up.

Boy with polecat

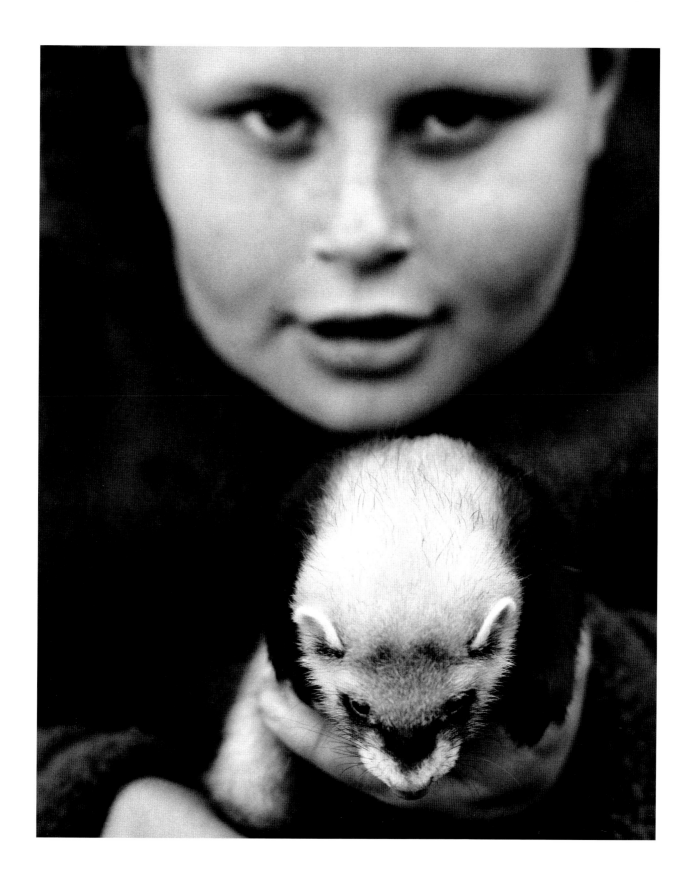

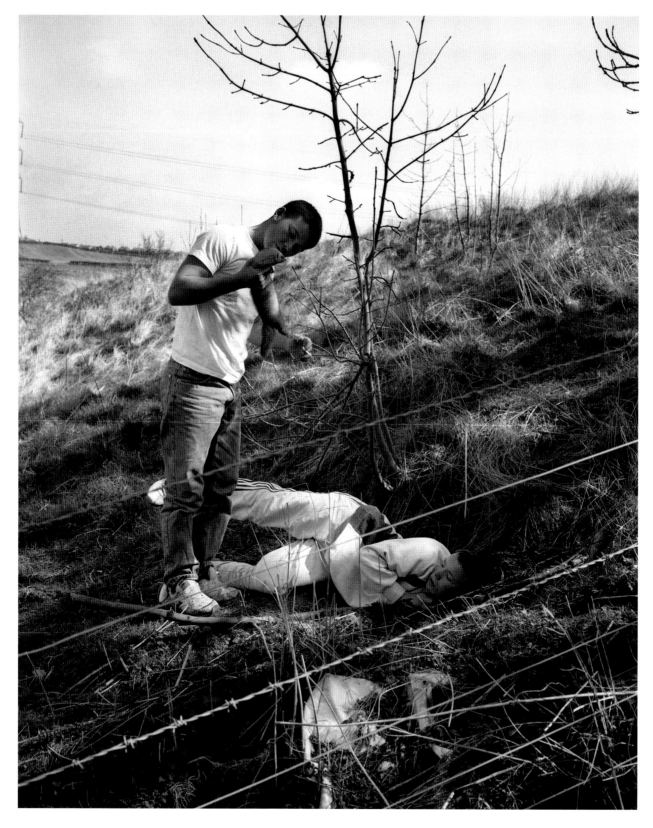

Hunting rabbits with ferrets

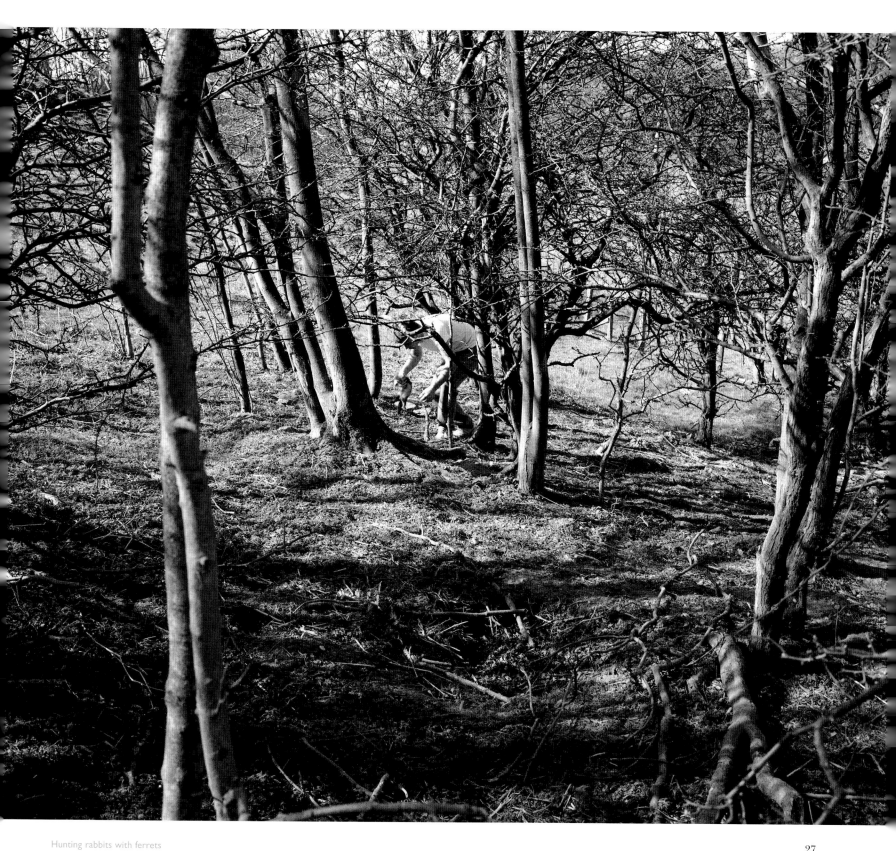

Hunting rabbits with ferrets

Wayne Armstrong hunting rabbits with ferrets and dogs

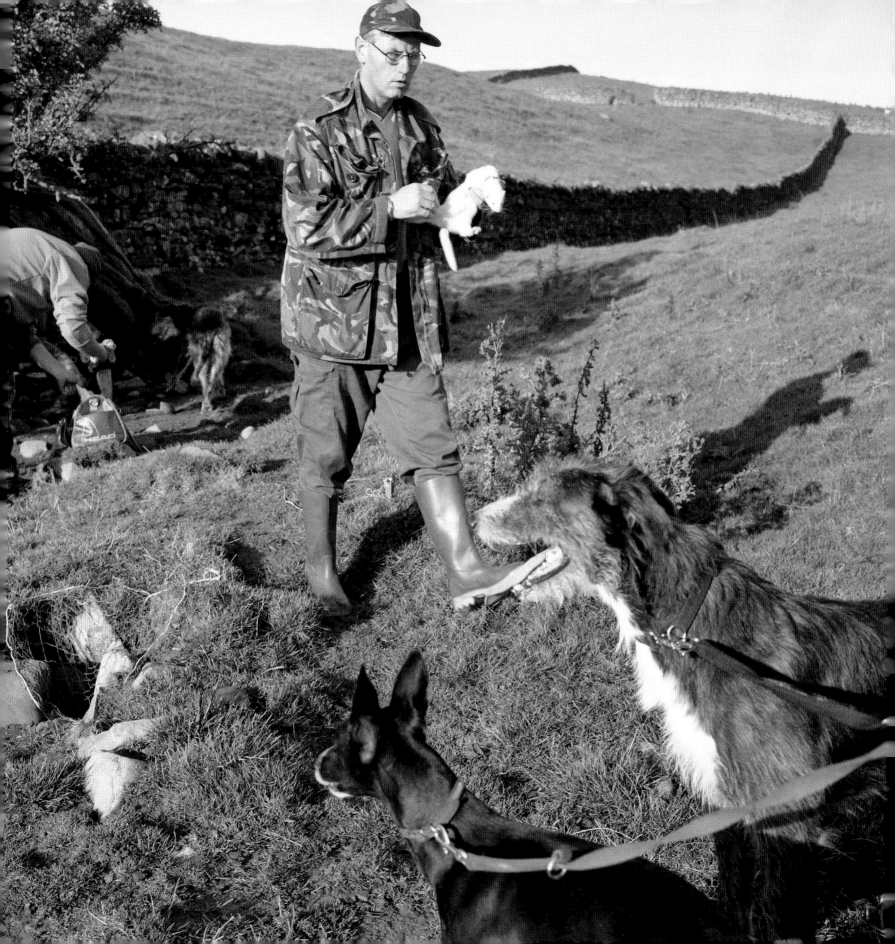

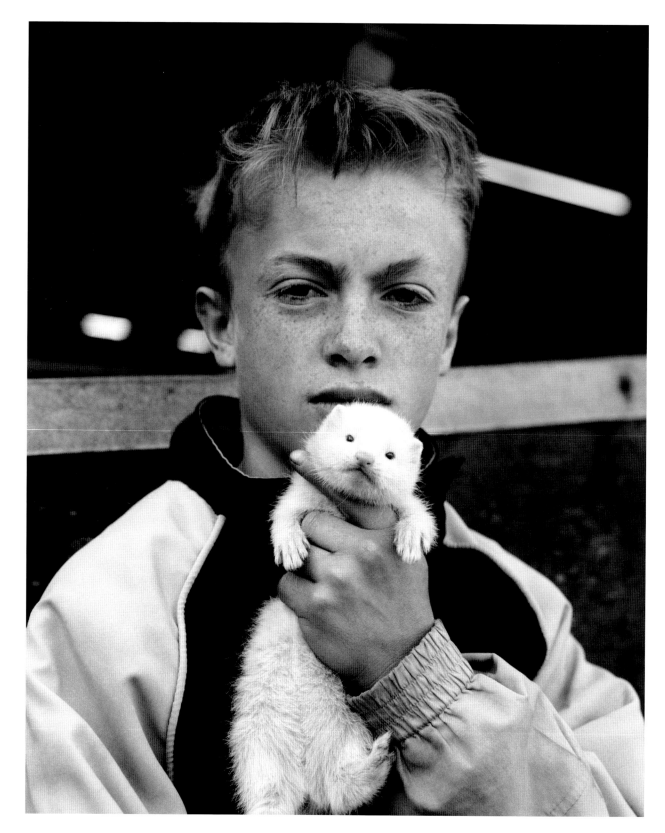

Boy with ferret

TROTTING

There is a flourishing business in trotting; horses to be traded and stud to be hired, apart from the money made and lost in gambling.

Harness racing involves having a horse attached to a small carriage, the sulky, which is like a small chariot. The discipline is that the horse must sustain a certain gait while racing. Either both legs on the same side of the body move at the same time, known as pacing, while moving the front and back diagonal legs in the same direction together is called trotting. In the North East, trotting is the main sport.

The sport evolved from road racing with horse and buggy, and it is still this form, though illegal, which most appeals to the travelling community. Usually held in the early morning on a straight stretch of road, a race can attract hundreds of followers. Normally the horse will be paired to a flat cart, not a racing sulky, and only two horses will compete. Trucks block off the stretch of road. Once over, the participants evaporate into the day.

Trotting race at Barnard Castle

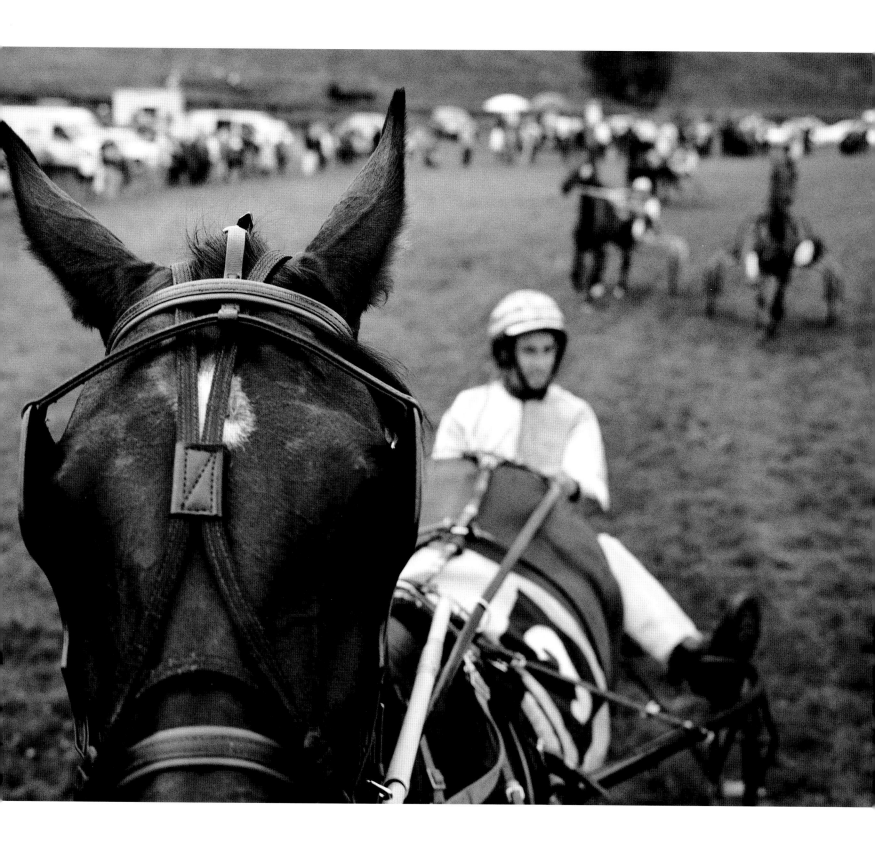

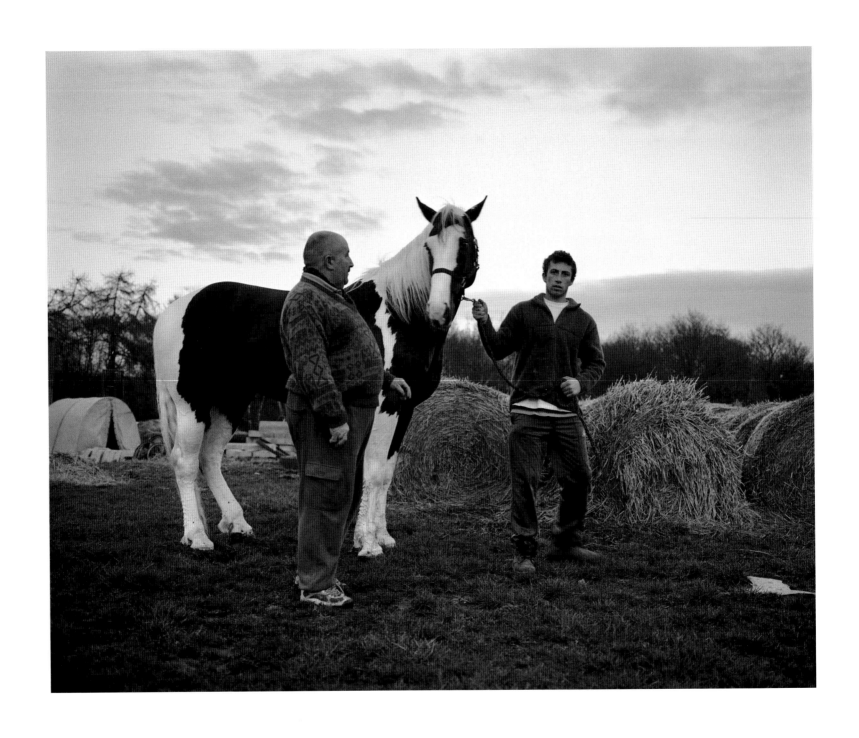

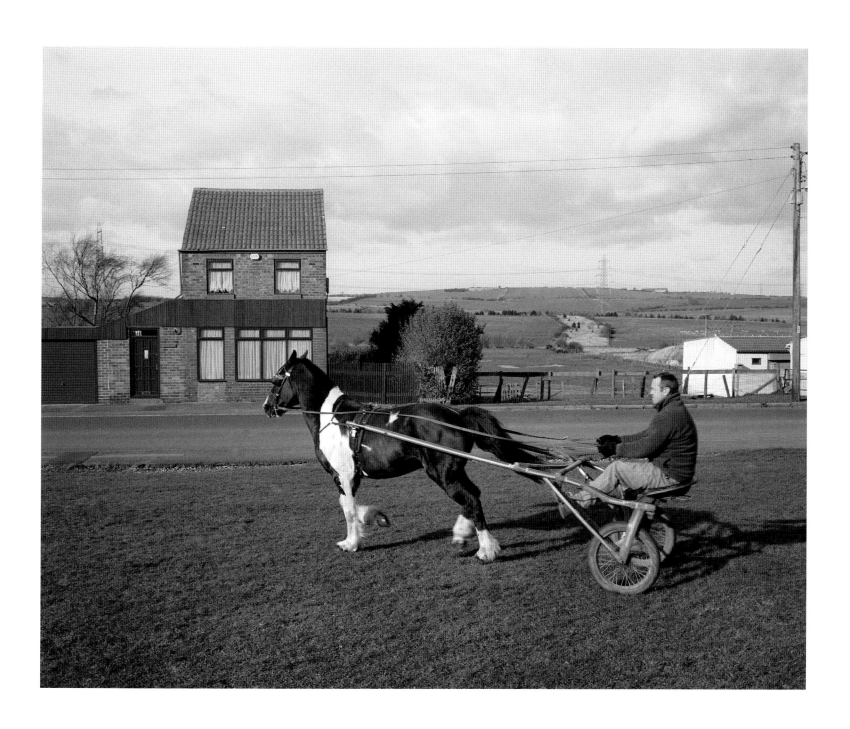

Training for trotting racer

Training for trotting racer

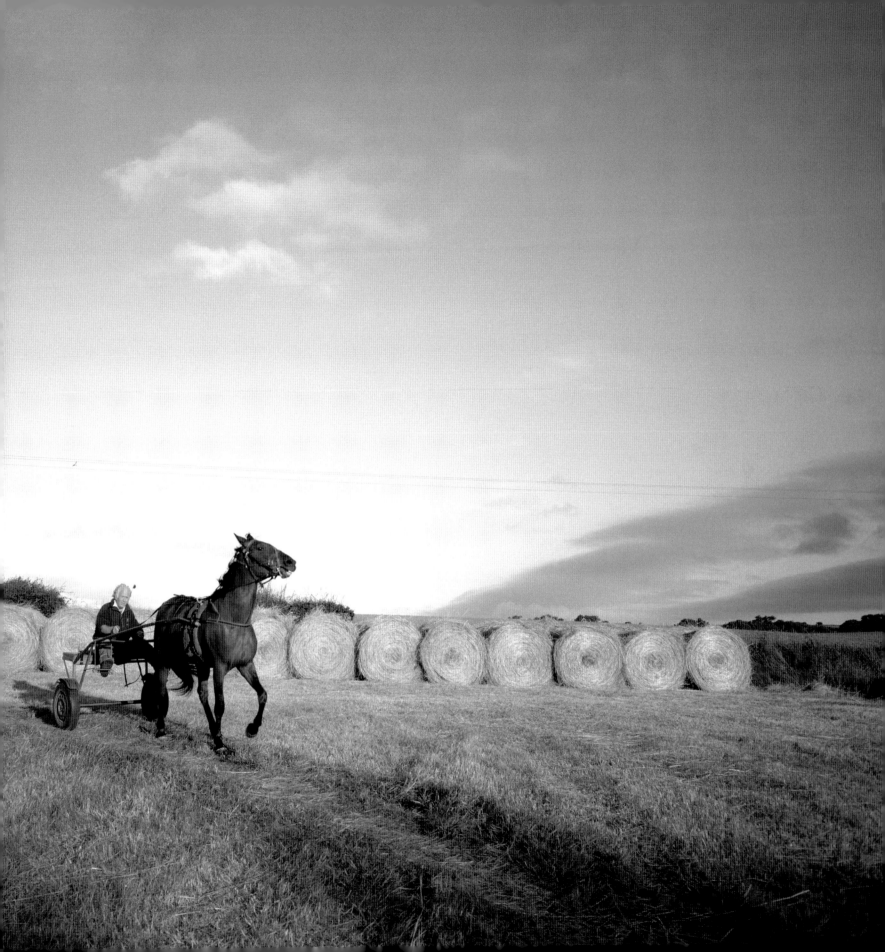

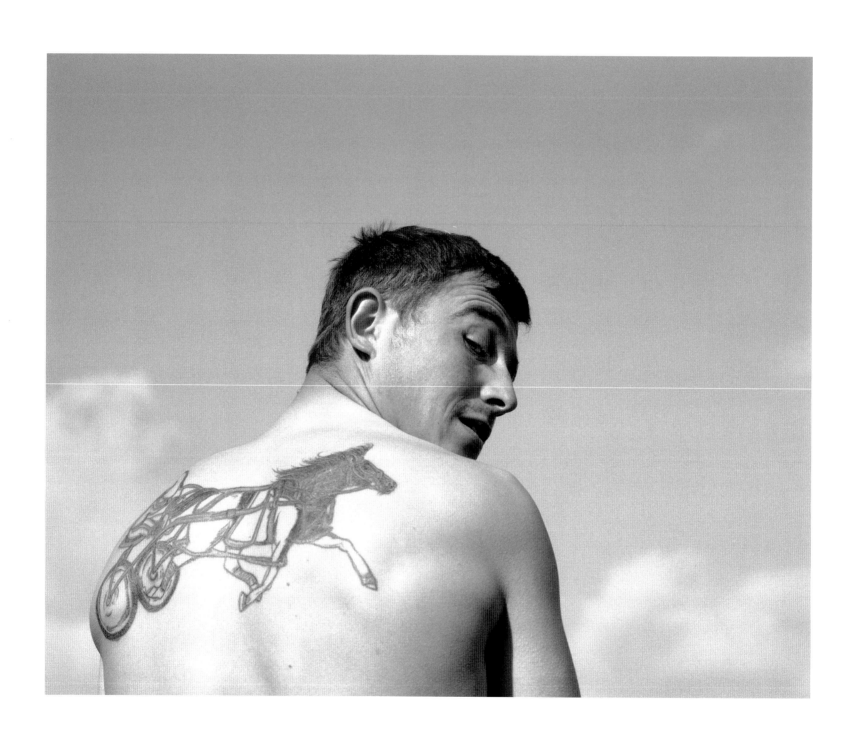

Carl Blankley's tatoo

FARMING

I spent relatively little time photographing farming. It seemed a topic in itself that would require a much longer time spent on it and a proper following of the seasons. At the same time, farming is present in almost every photograph, its history, traditions and current practice moulding the whole landscape.

As someone who enjoys gardening, and knows how difficult it is keeping that small patch of land under control and productive, it is chastening to observe the functioning of a well managed farm; the co-ordination of livestock and crops, land and season, investment and return, work and leisure, in a seemingly seamless whole.

New-born lamb

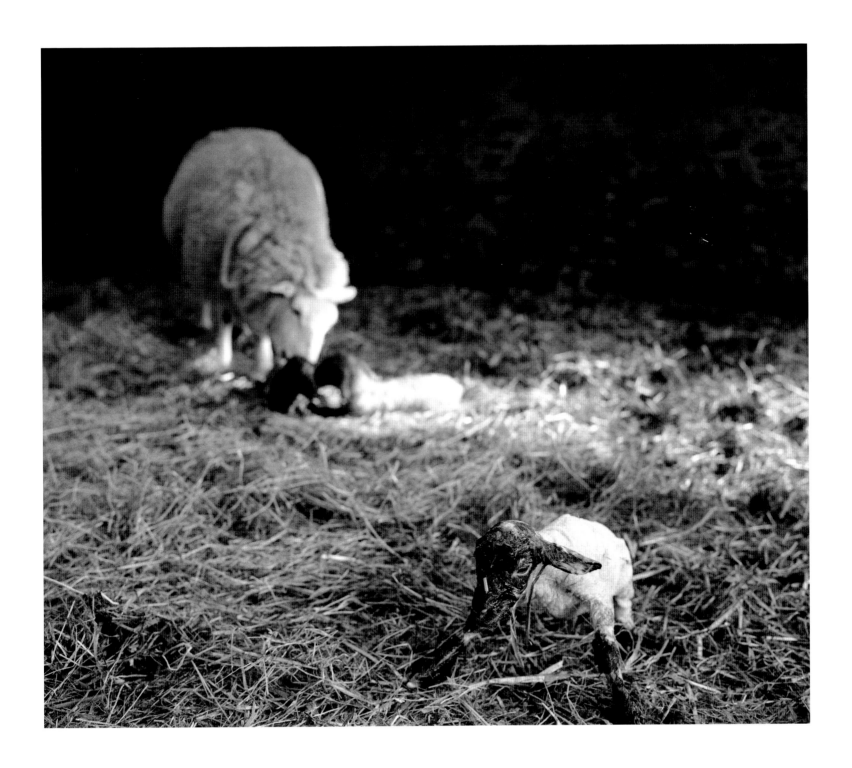

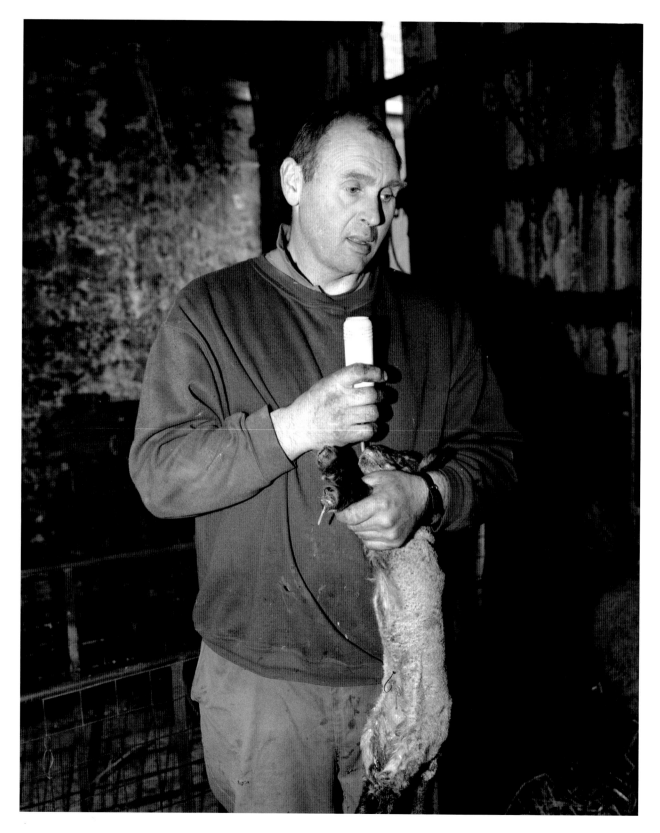

Brian Rutherford feeding a new-born lamb

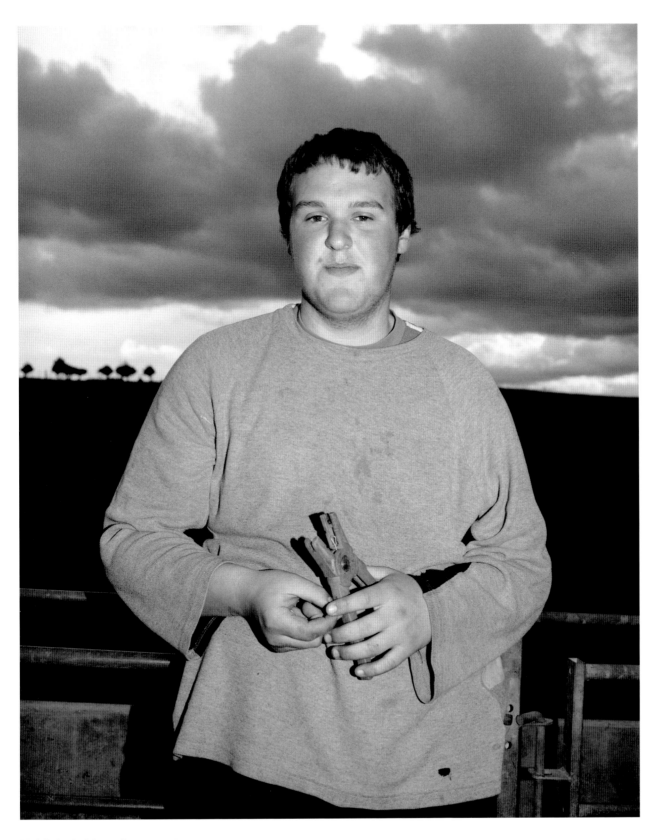

Mark Rutherford during sheep ear tagging

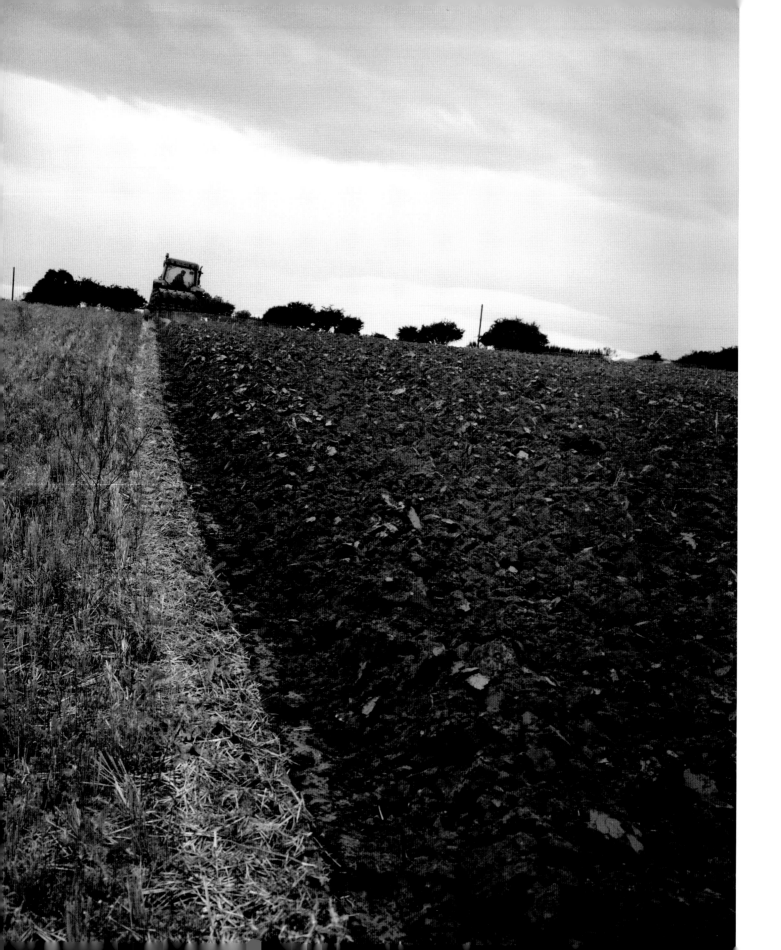

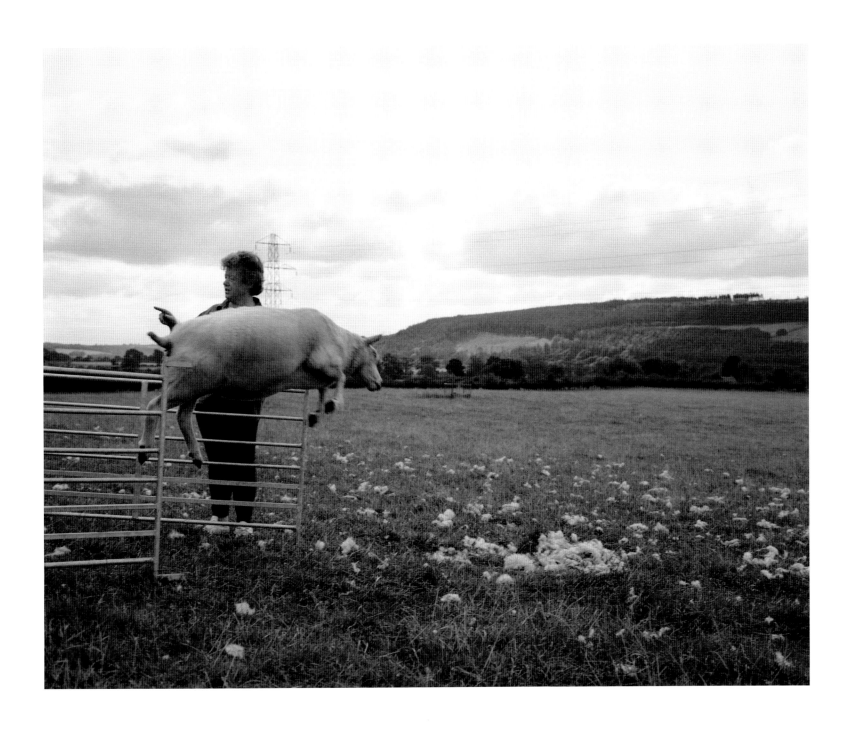

Left: Ploughing
Above: Counting sheep

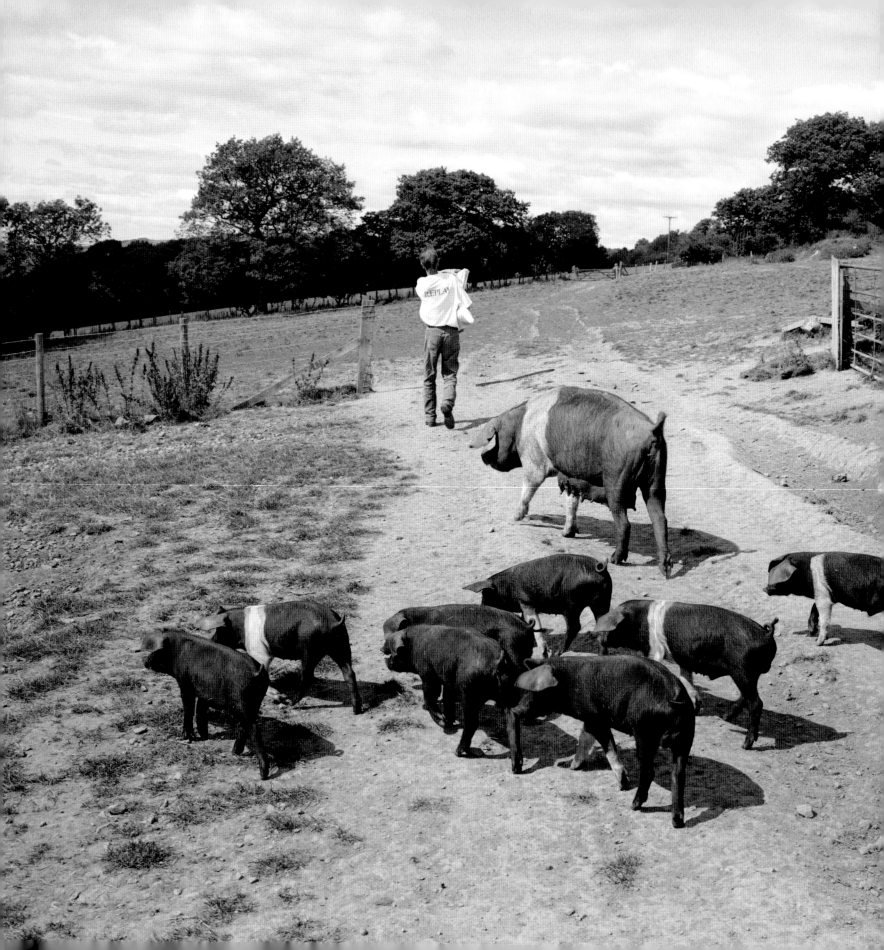

Organic pig farmer David Pike

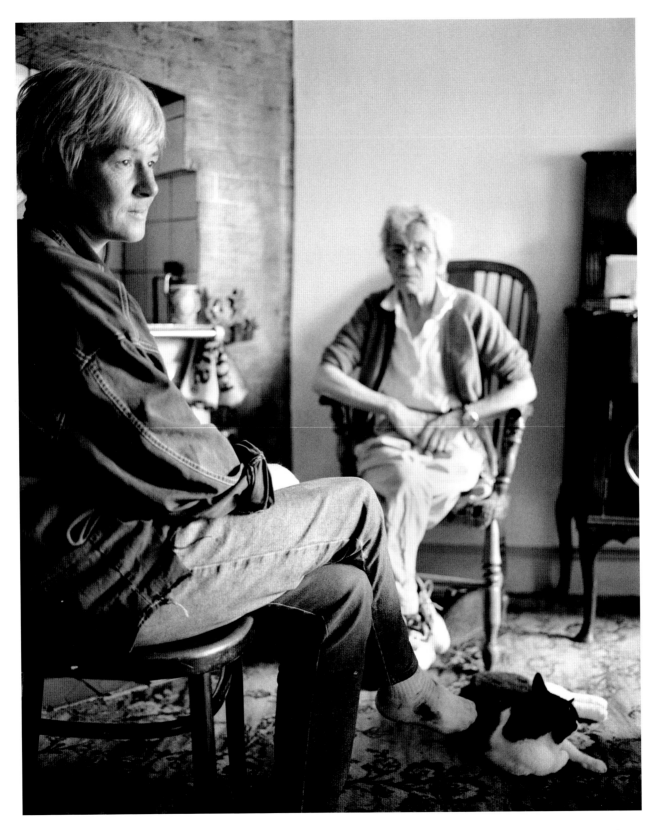

Jean Thompson and her mother Winnie. Sheep farmer

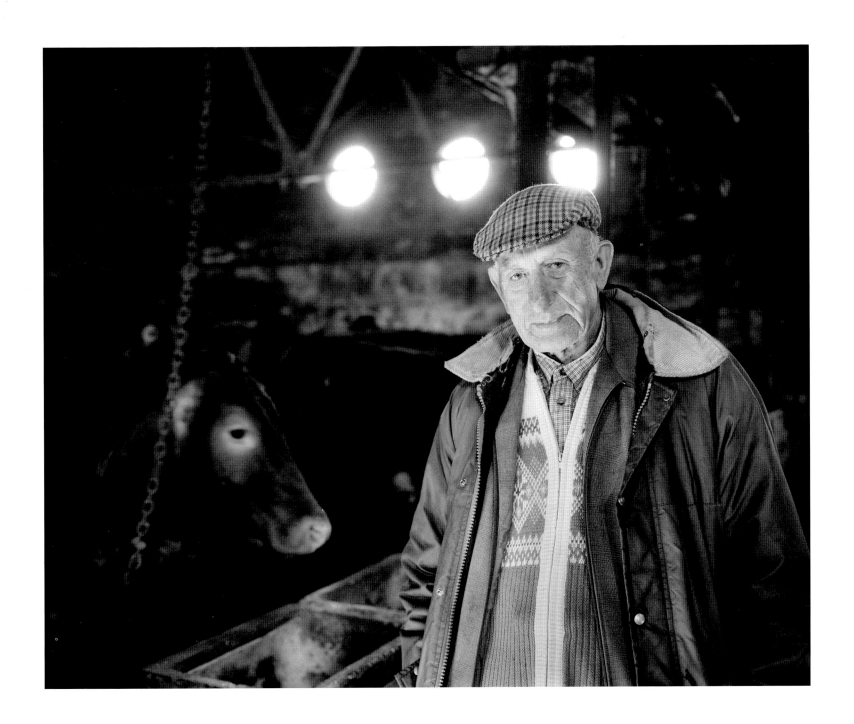

Jack Robinson in cow-shed

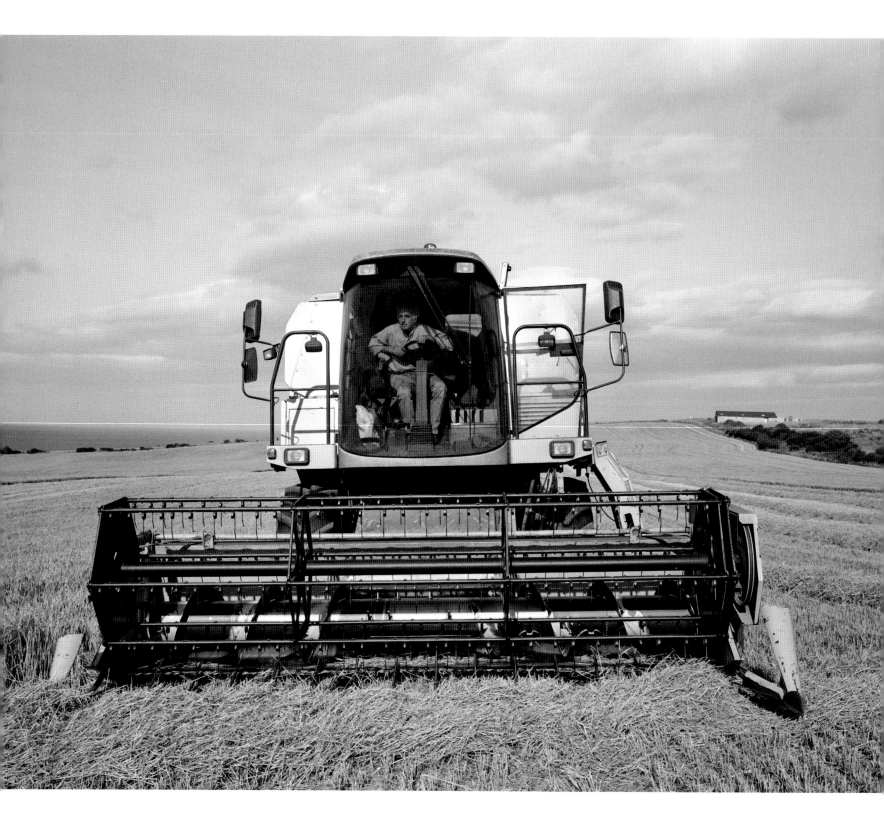

Alan Howard in a combine harvester

Milking time

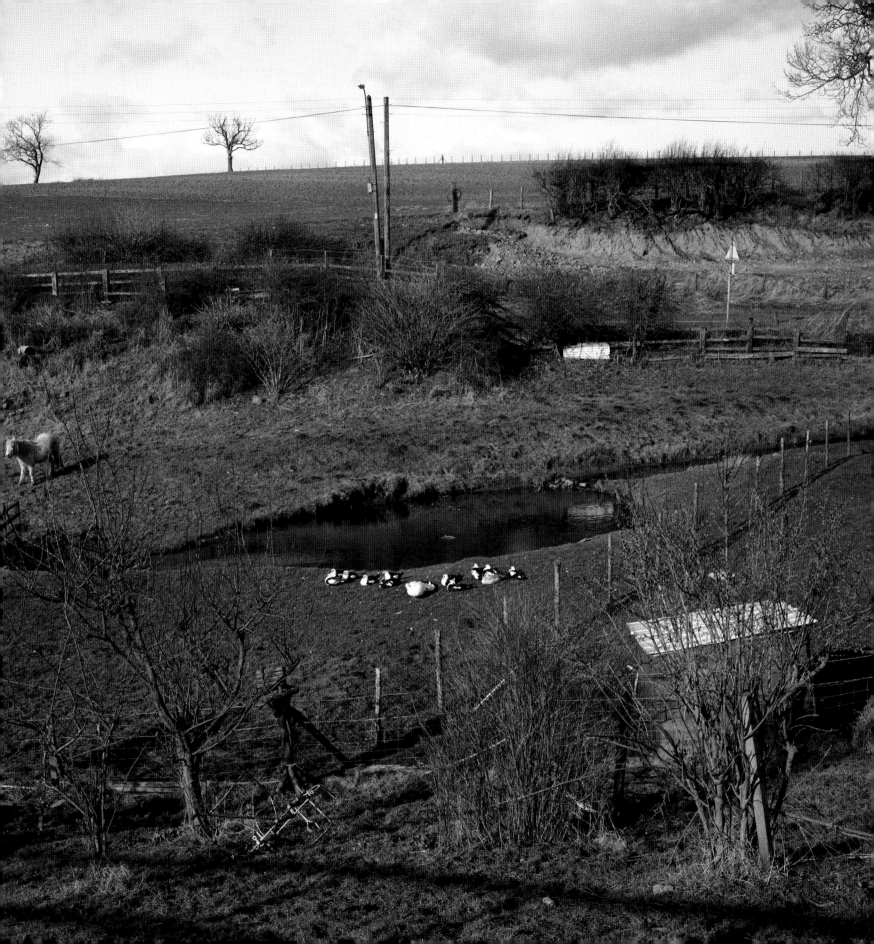

SHOOTING

As you move west across Durham and into the Pennines, there is more money and shooting rights are valuable. Grouse are more difficult to shoot than pheasant as grouse come in low and fast and, because of that, accidents can happen. The undisciplined shooter pans too far with his (it is almost exclusively men who seem to shoot grouse) gun and ends up peppering his neighbour or his loader. Pheasant fly higher but tend not to be in flocks the way grouse are. Both birds are usually flushed out by hired beaters who, waving cloths and shouting, drive the birds from their hiding places towards the guns, and then dogs are used to retrieve the fallen birds.

Ducks are generally not flushed out; they require more patience. They must be shot in flight as we all know how un-sporting shooting a sitting duck is.

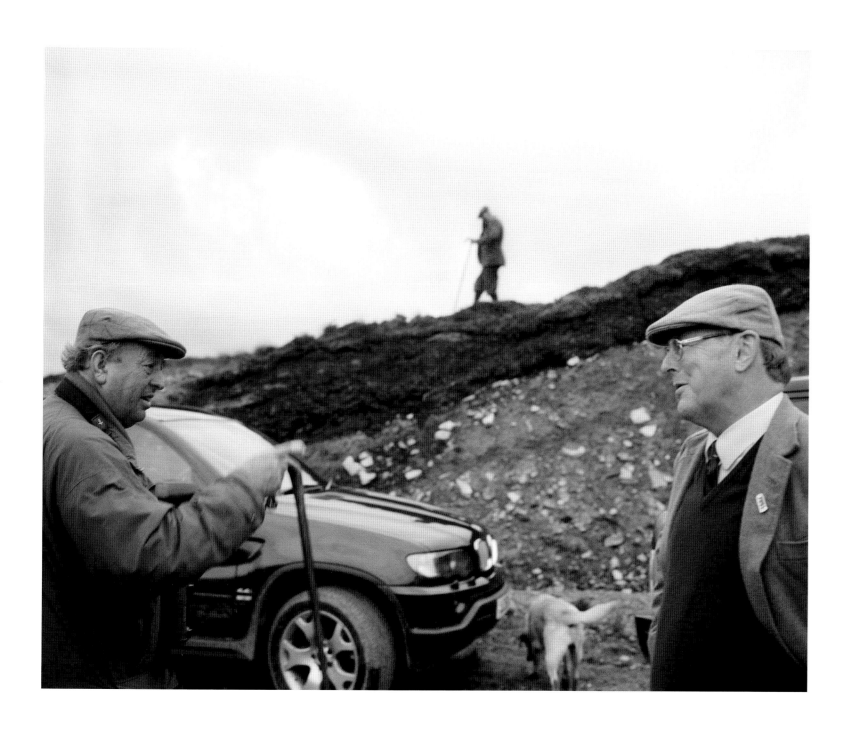

Preparing for a grouse shoot

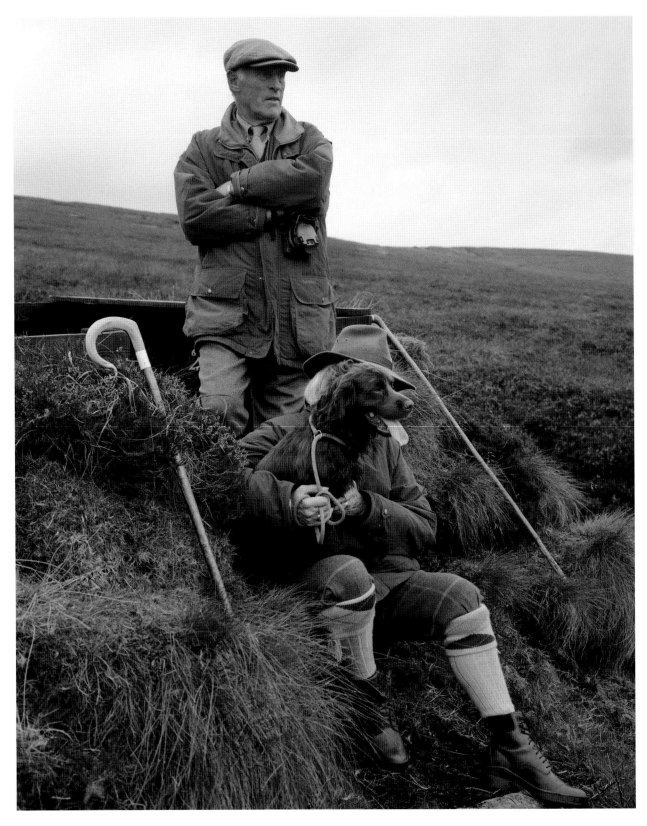

Waiting at the butt before a grouse shoot

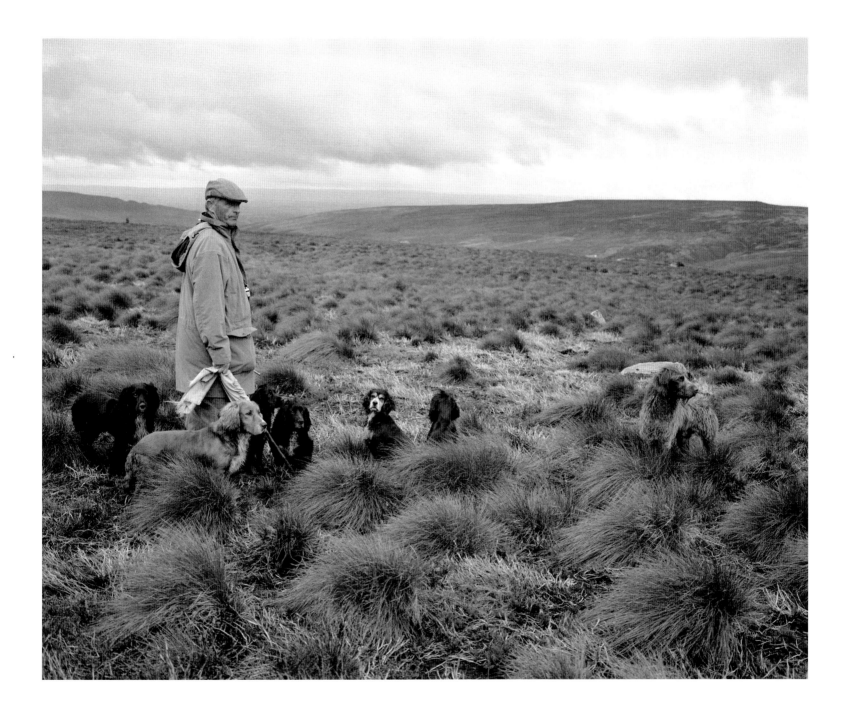

Lindsay Waddell, Head Gamekeeper on the Raby Estate, during a grouse shoot

Beater during a grouse shoot

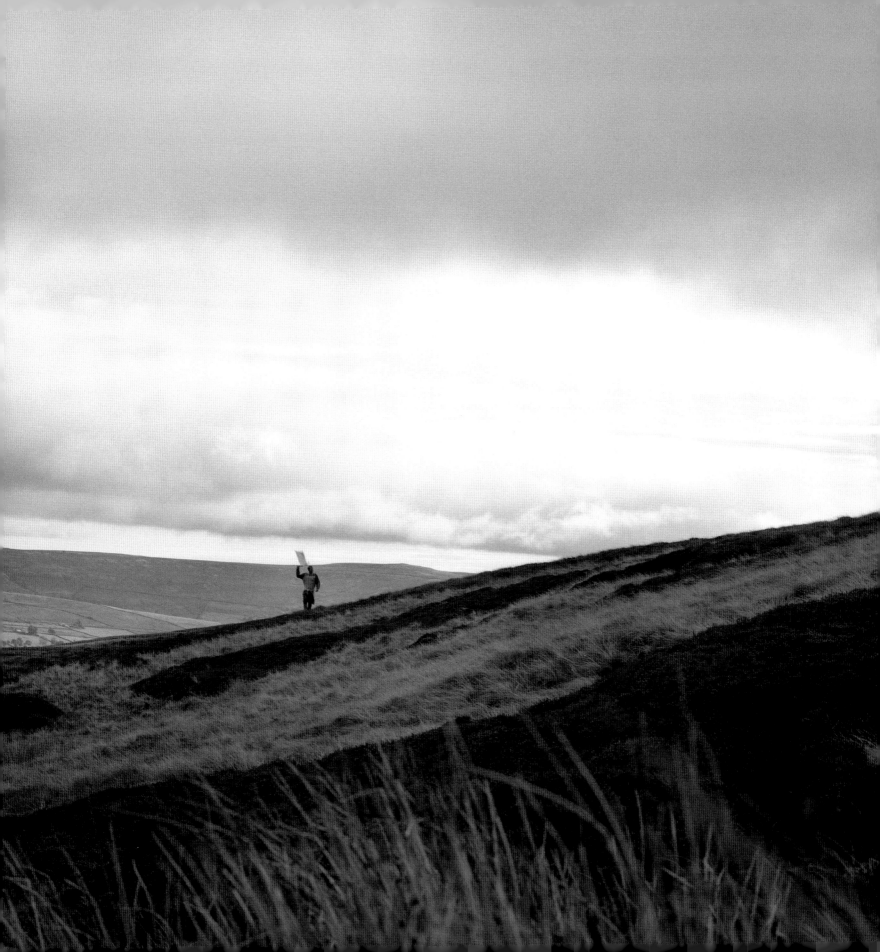

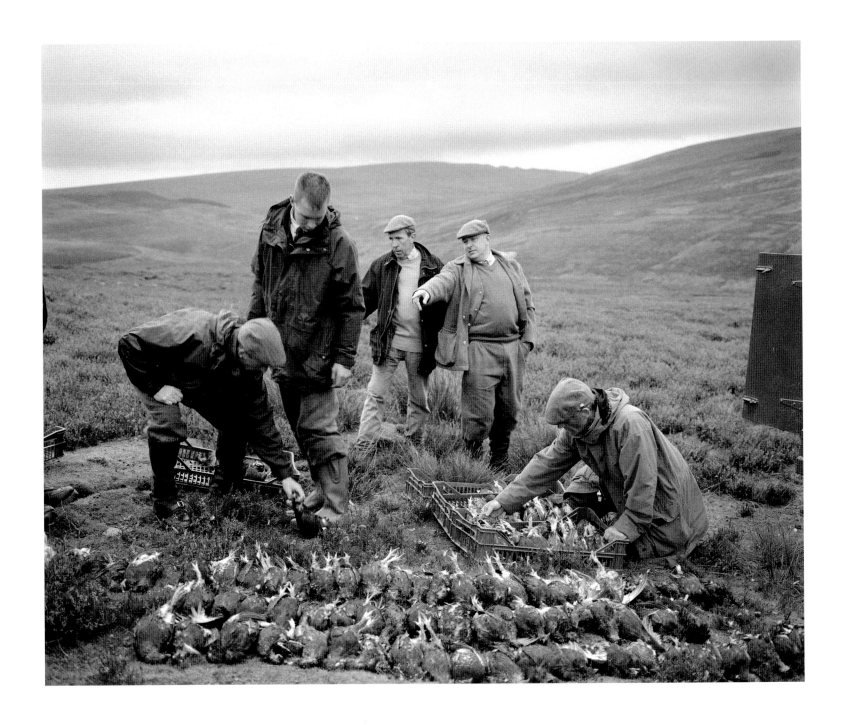

Counting the grouse after a shoot on Raby Estate

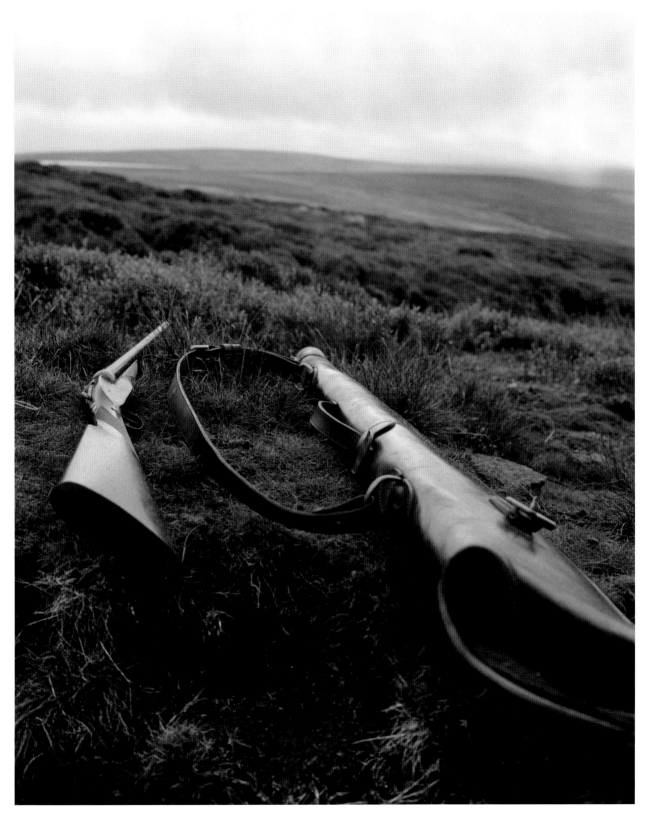

Gun at the butt during a grouse shoot

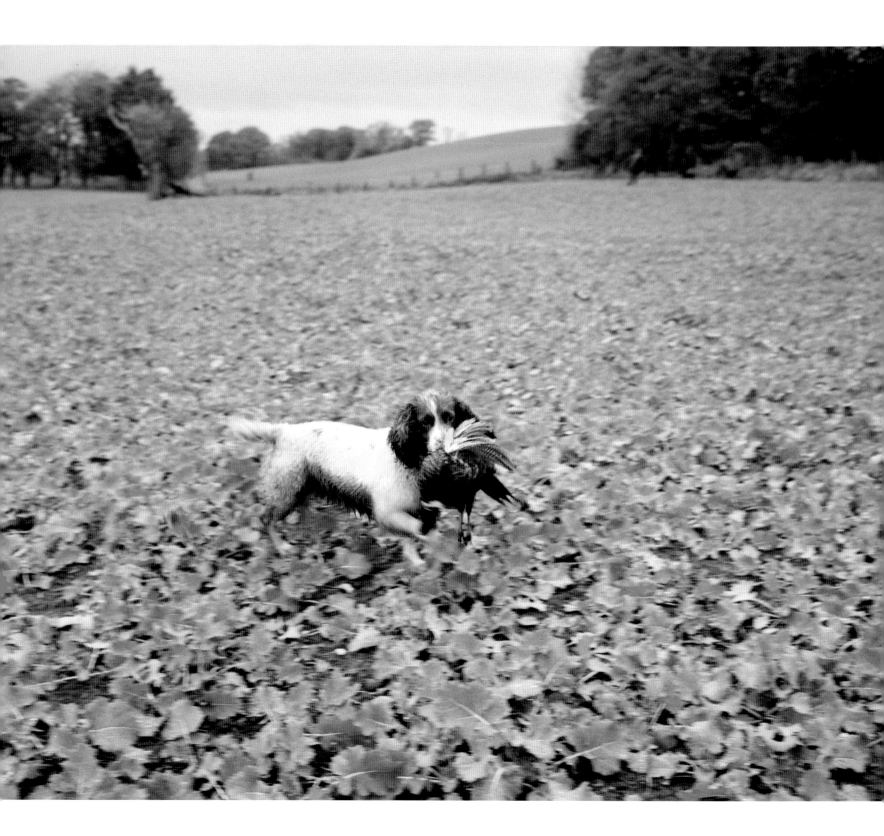

Retrieving pheasant

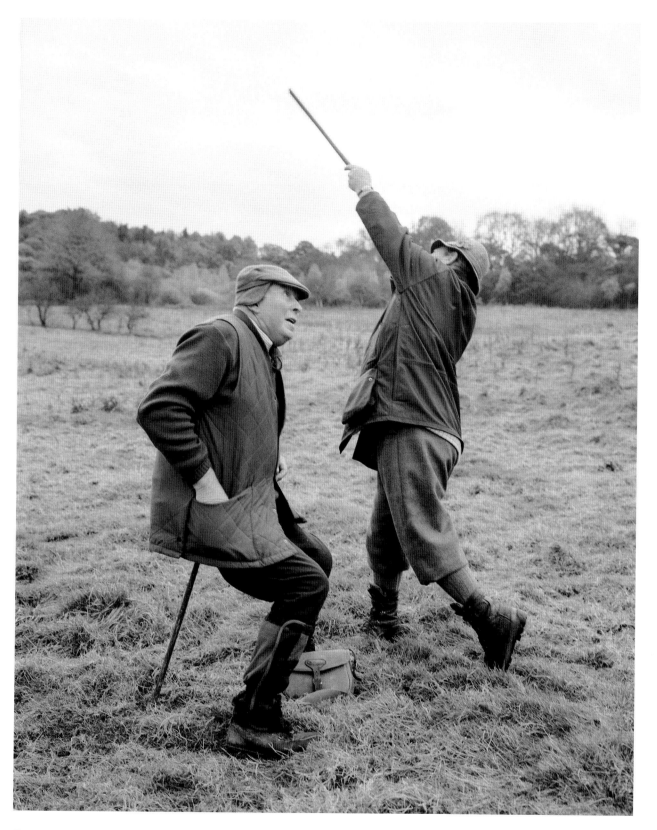

Pheasant shooting

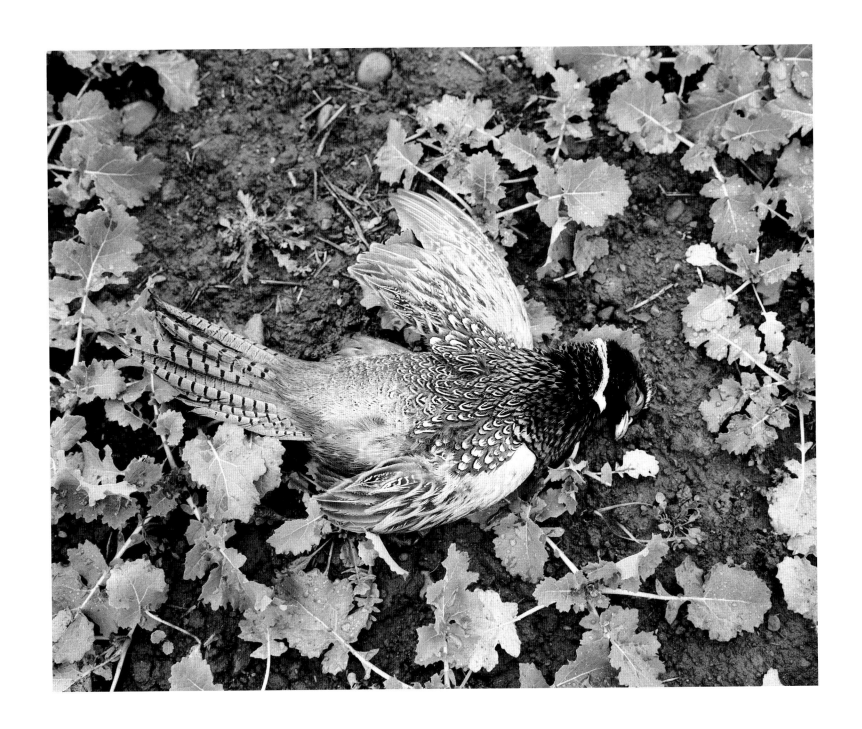

Shot pheasant

LAMPING

In Britain lamping is most commonly a technique for hunting rabbits, which are a serious pest for farmers, but it is sometimes used on other animals such as hare, fox, deer and badger.

At night a powerful lamp is used to spot the rabbits, which come into the open to feed. The rabbits can then be shot, or chased by dog(s) which are usually lurchers or greyhounds. The rabbits caught are often cooked and eaten.

The current law only allows the killing of badger if specially licensed, and now only allows the hunting of rabbit and rat using dogs. Other animals can be lamped, but they must then be shot.

Lurcher jumping a wall while out lamping for rabbits

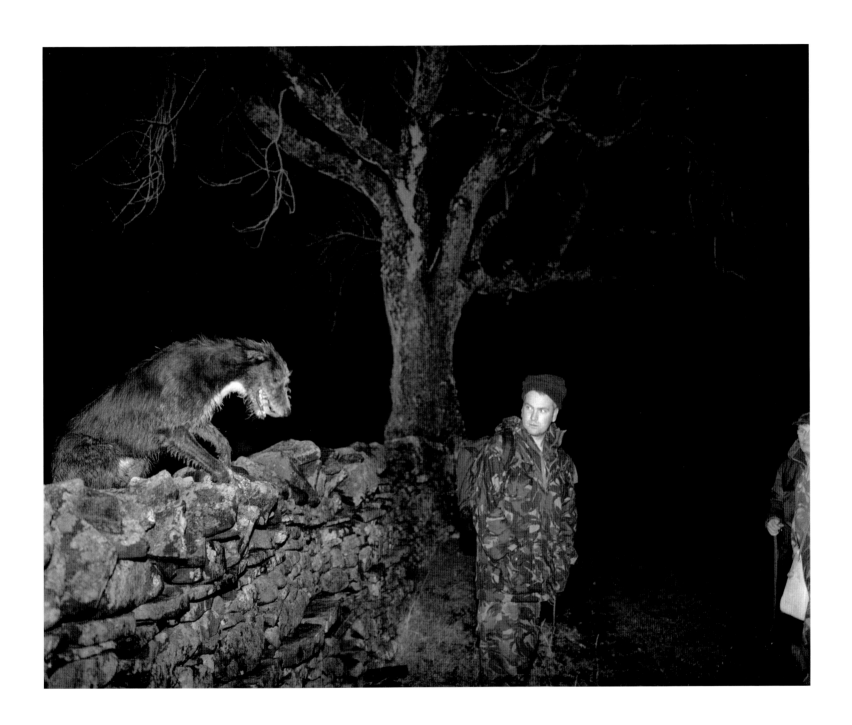

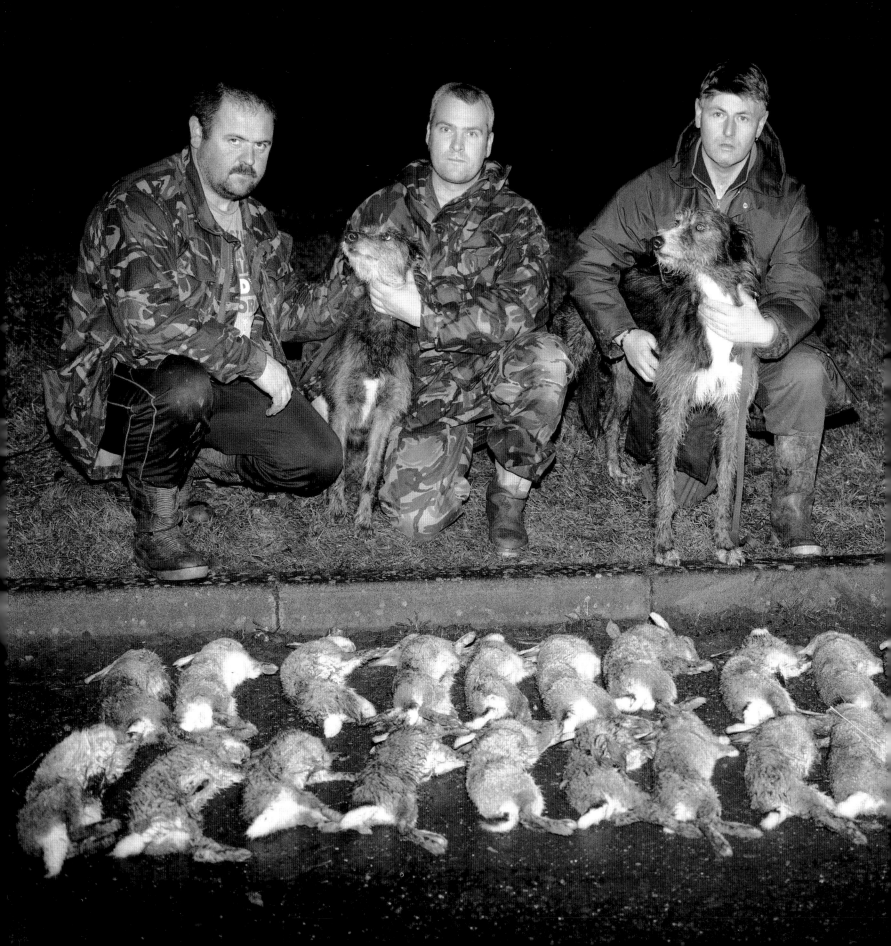

Night's catch of rabbits after a session lamping with dogs

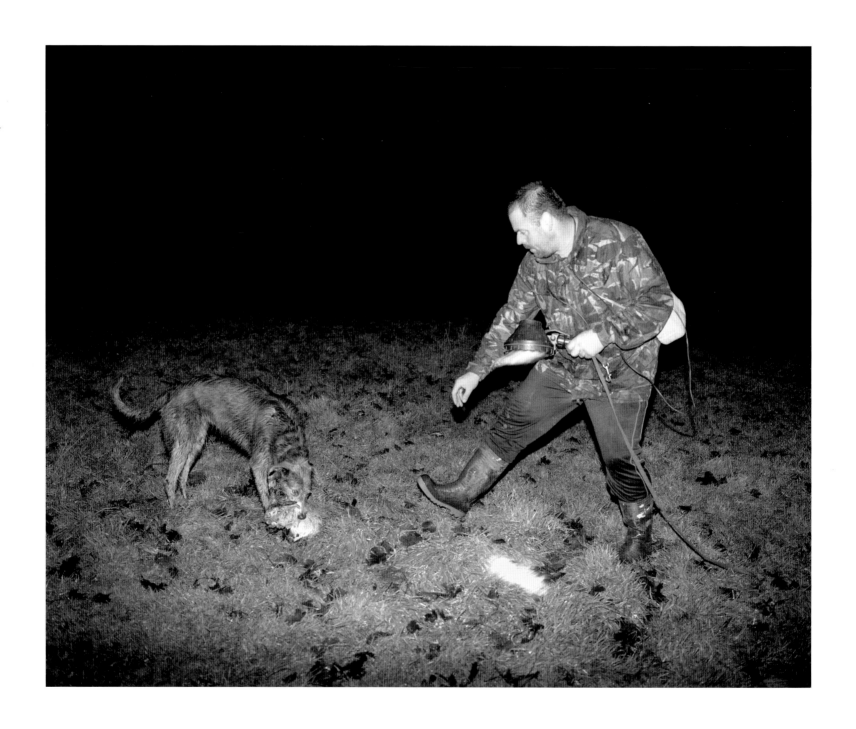

LEISURE

Touching on the topic of leisure the viewer will be aware of how much is not here, and indeed, how much of what I have grouped under other chapter headings, could be in this one. So many country fairs, harvest festivals, bonfire parties, vegetable competitions missed. So many as to make a whole book on those subjects alone.

I make the vague distinction that activities like hunting, although carried out as a leisure pursuit have a practical purpose, the control of vermin, whereas this collection of images are just about people having fun, whether looking after pet horses or training whippets.

Point-to-point

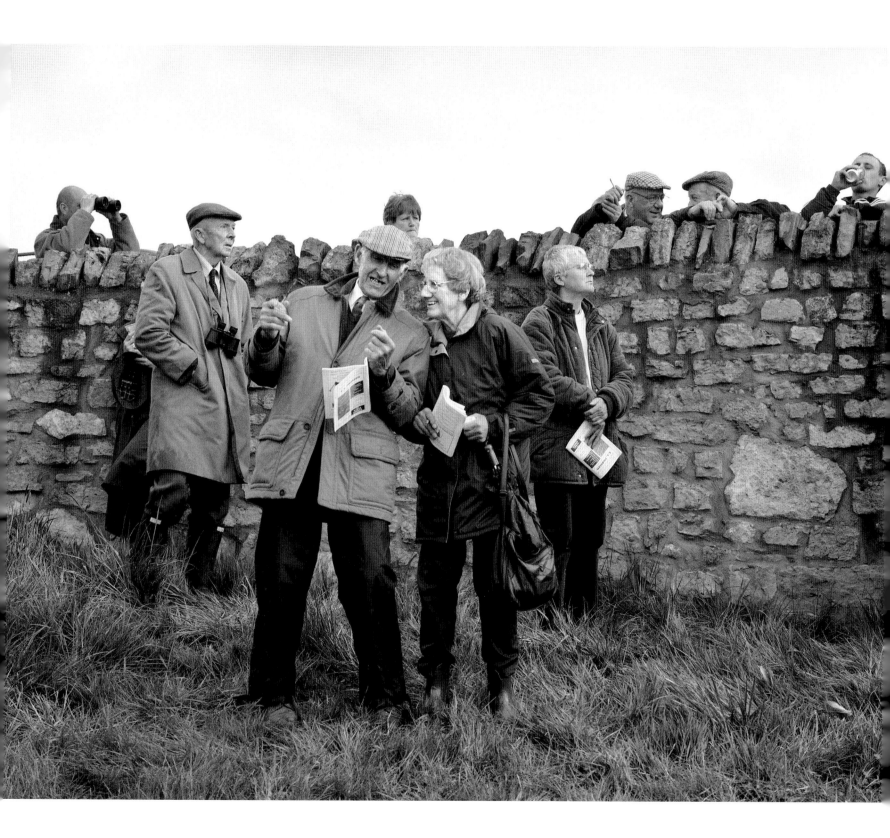

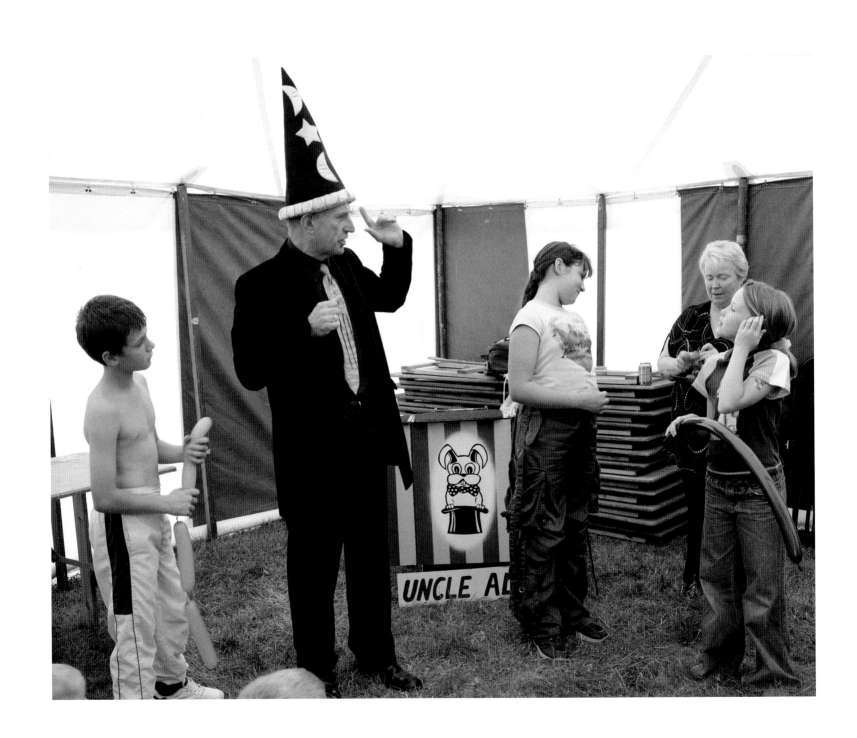

Haswell Plough Fair

74

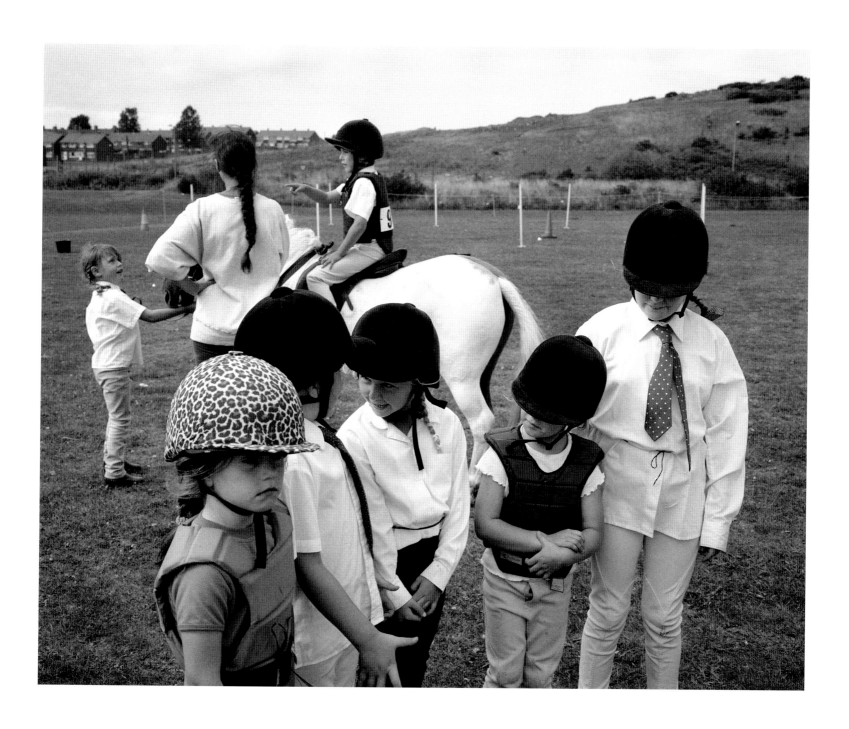

Children's pony contest

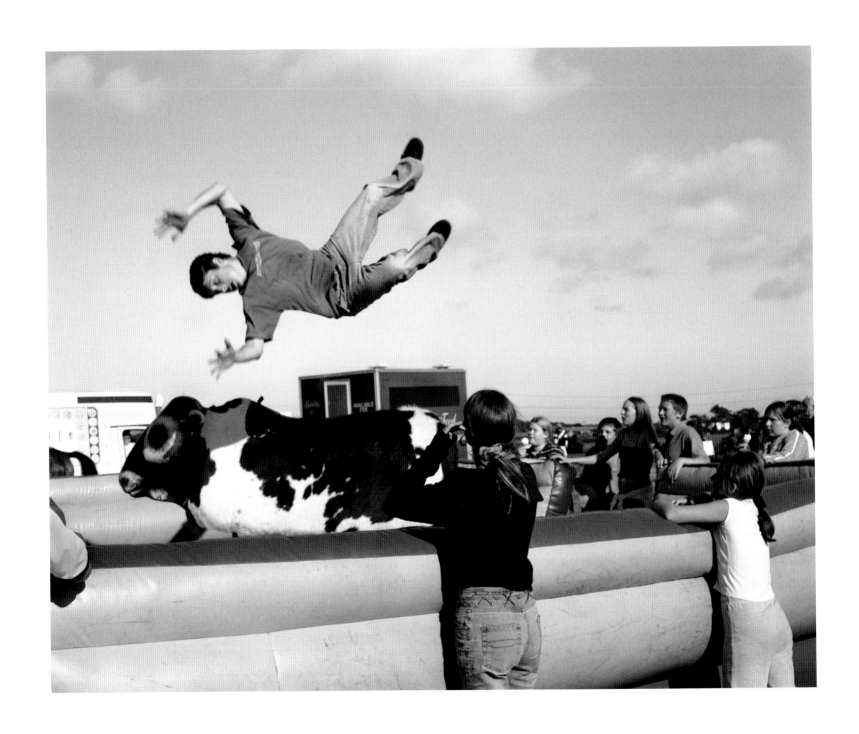

Haswell Plough Fair

Rock and Rennington Scarecrow Festival

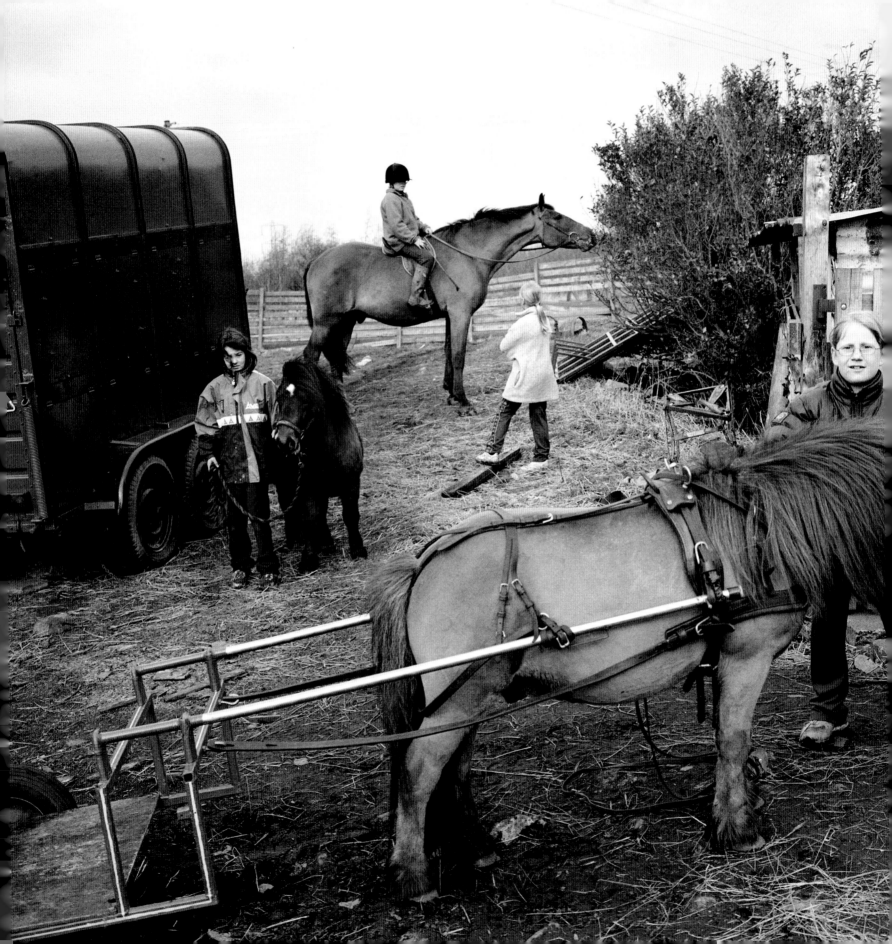

Children with their ponies and horses at Haswell Plough

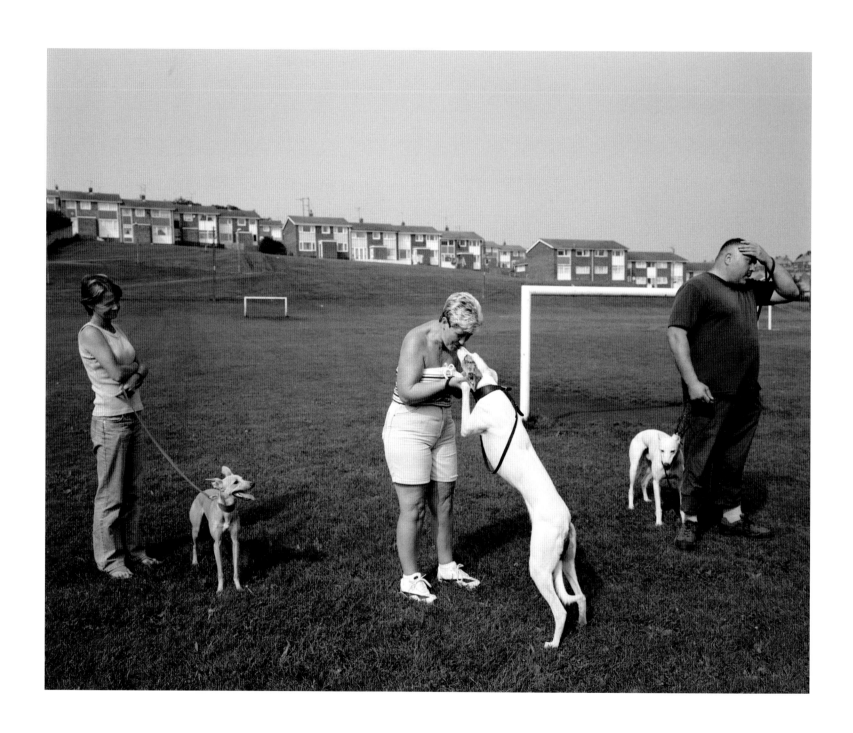

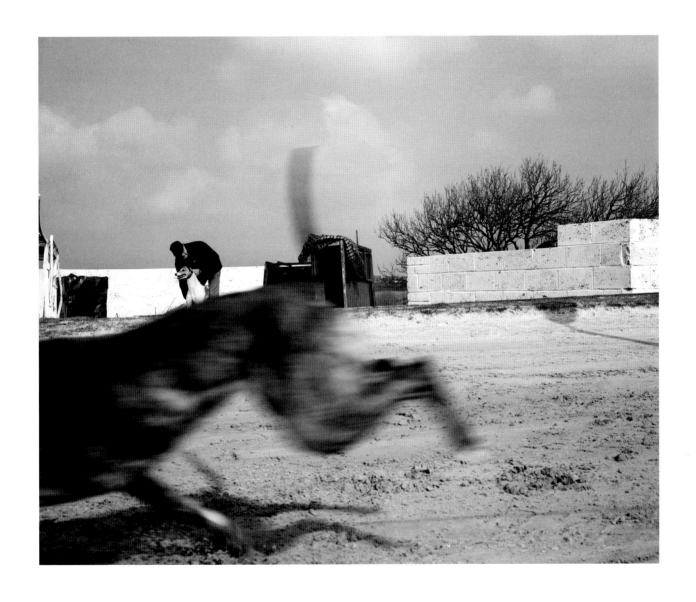

Greyhound racing at Easington

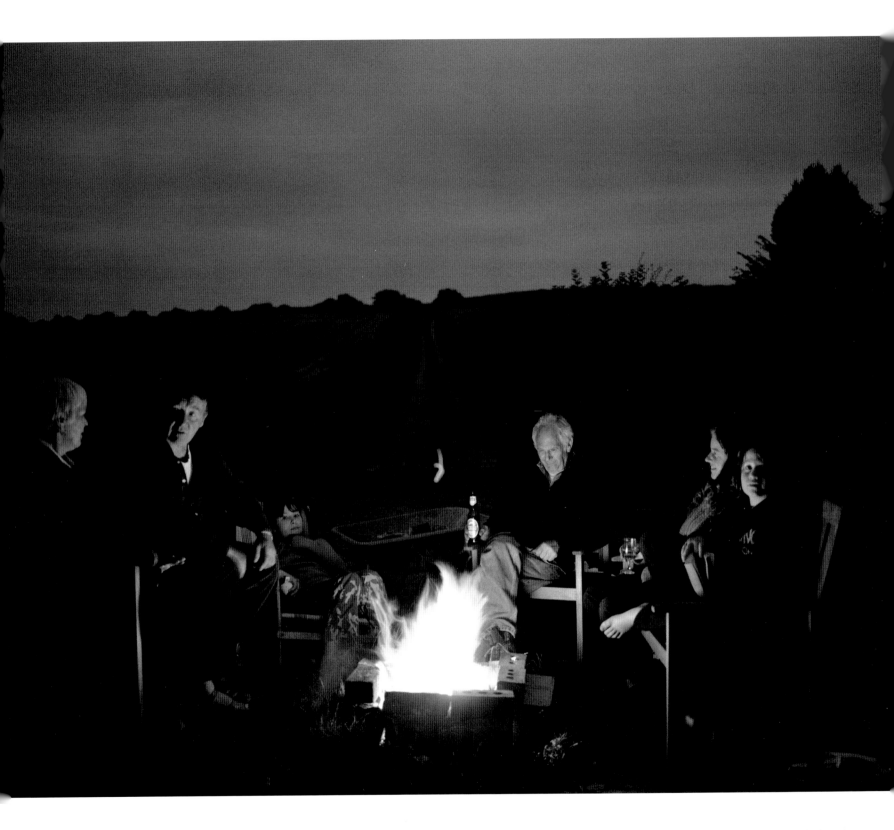

Murray, Ellie and Mattie with guests at a barbeque

HASWELL PLOUGH MART

Haswell Plough Mart is a remarkable place. If you want a chicken, a ferret, a bag of rusty nails, a broken saw blade, a potted plant, a door, some tyres, harness, sometimes a car, potatoes, painted mugs, some railings or perhaps a horse, this is where you need to come.

 It takes place every weekend in a barn, and seems part business and part ritual. It was the starting place for my work on this book. The contacts I made there led to other contacts and to others in a domino effect, and looking back I wonder if I could have done the work without this focus.

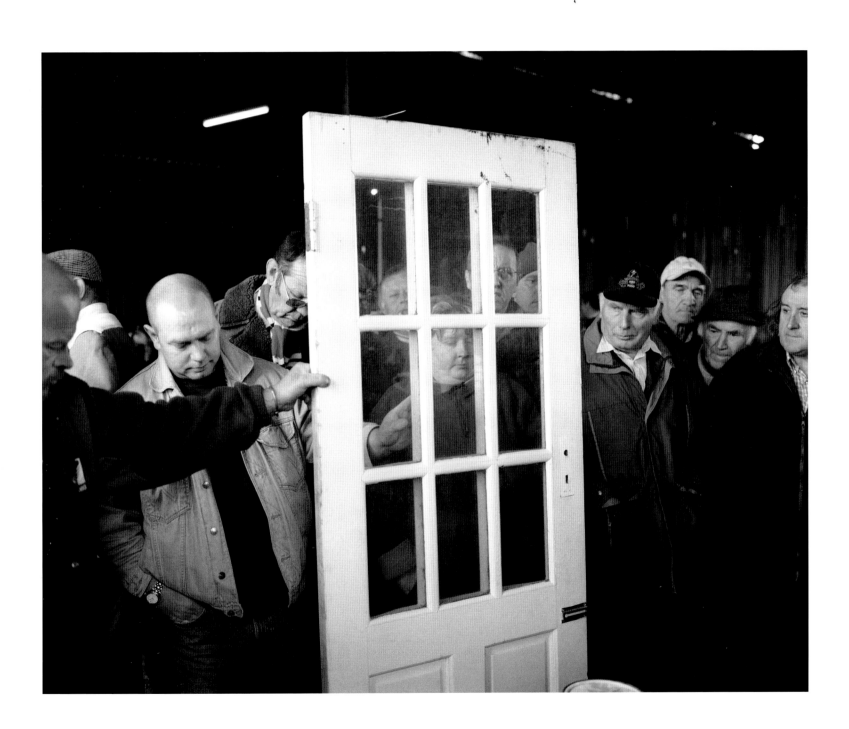

Haswell Plough Mart. Sale of a door

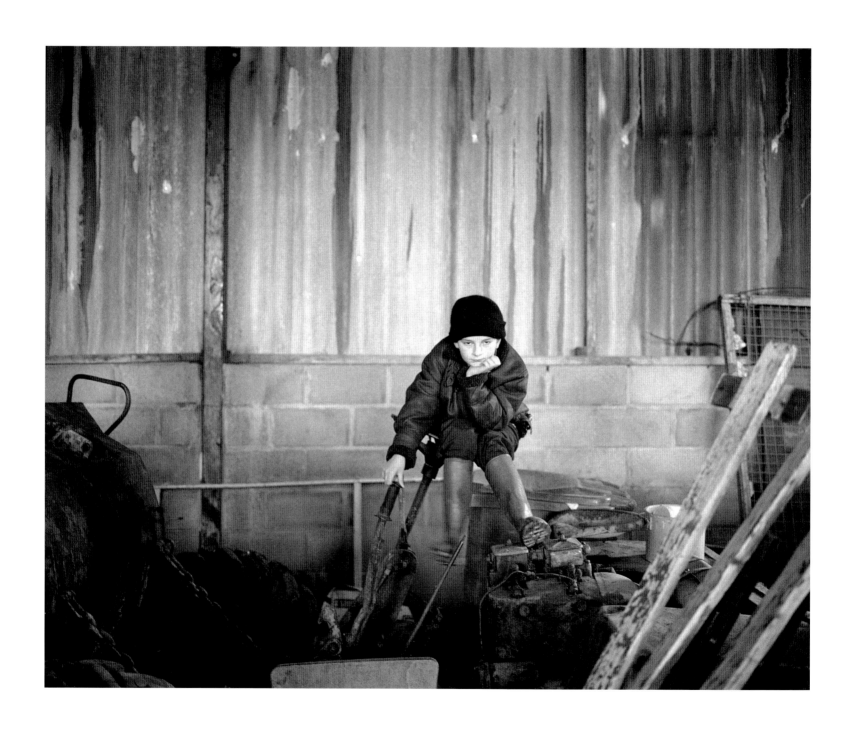

Haswell Plough Mart

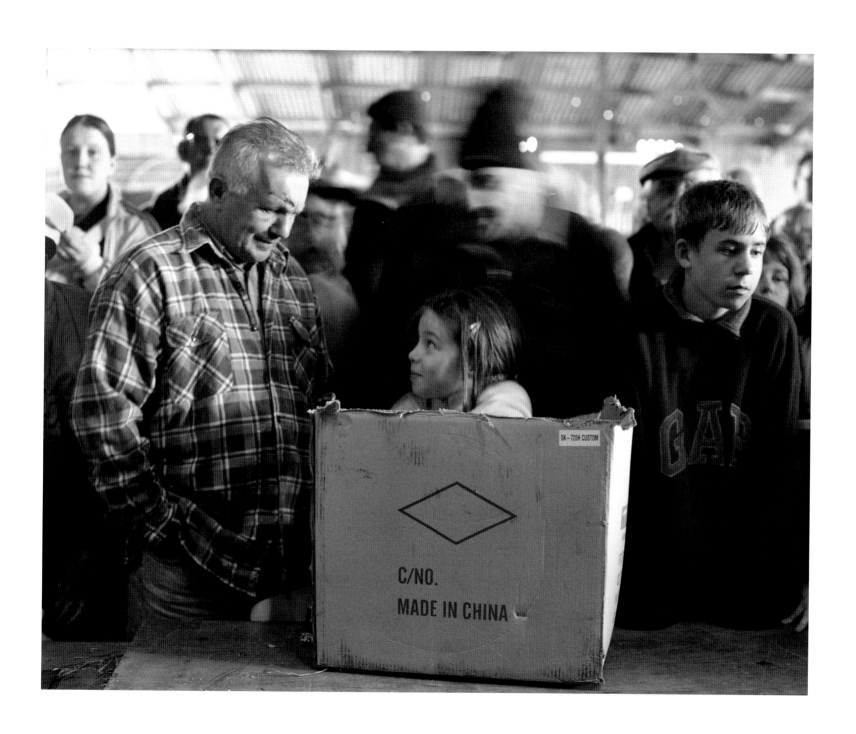

Haswell Plough Mart. Auction of animals

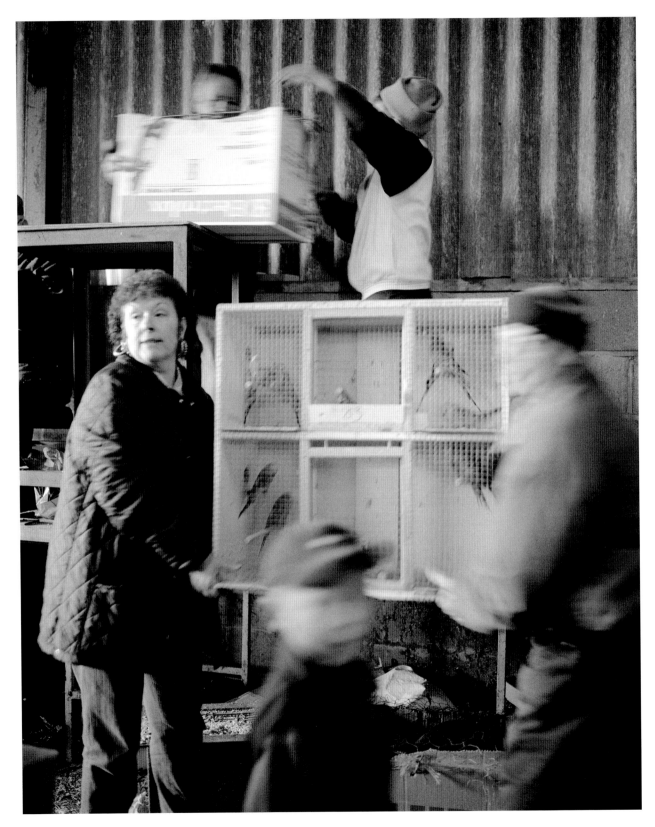

Haswell Plough Mart. Auction of birds

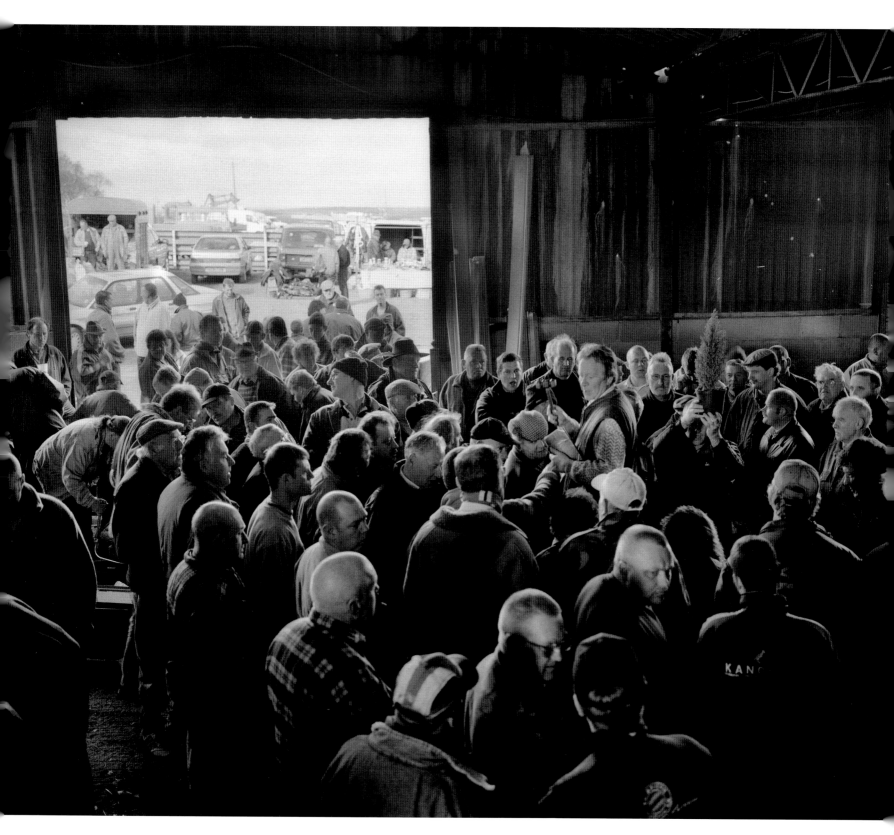

Haswell Plough Mart. Auction of plant

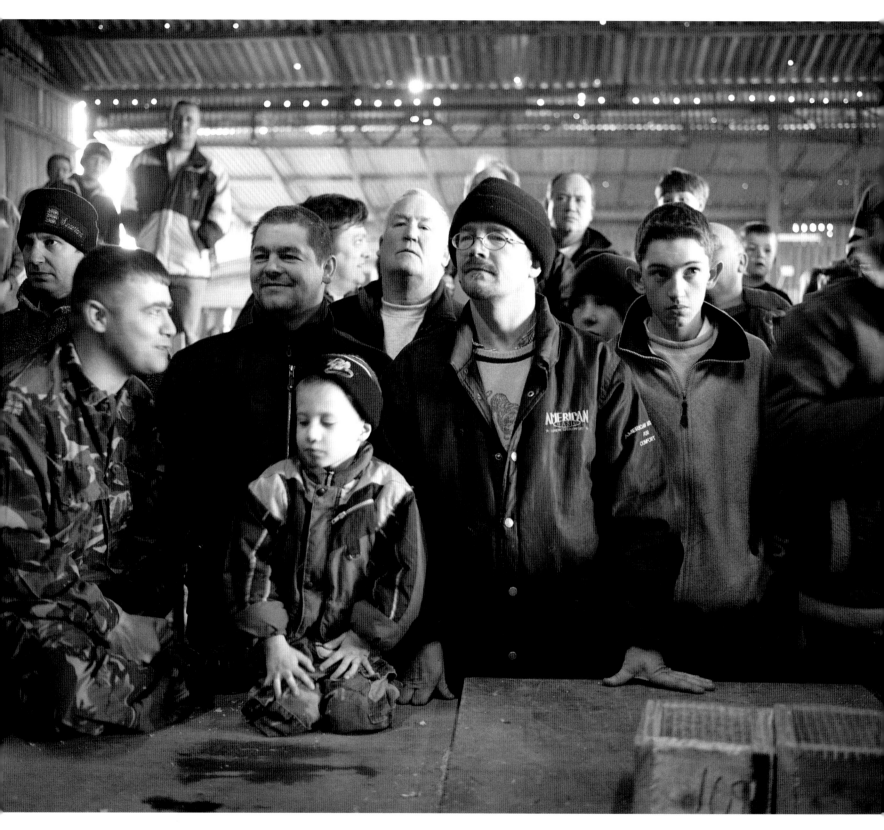

Haswell Plough Mart. Auction of animals

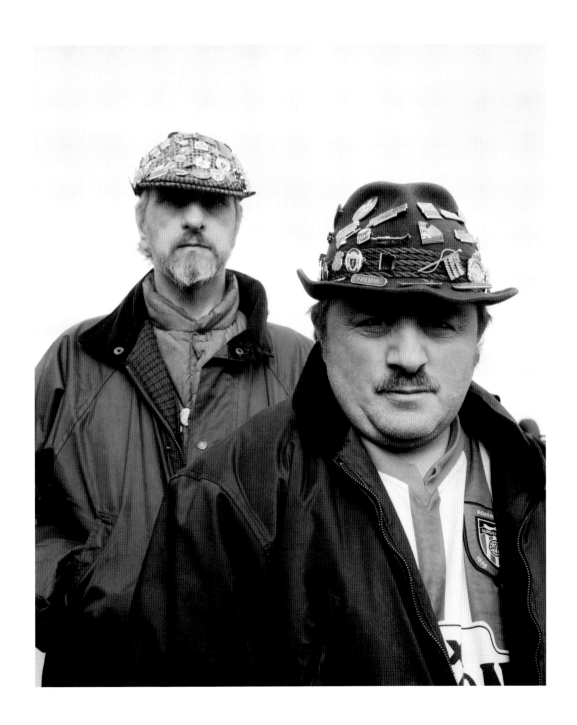

Haswell Plough Mart. David Lee and Morris Abbot (front)

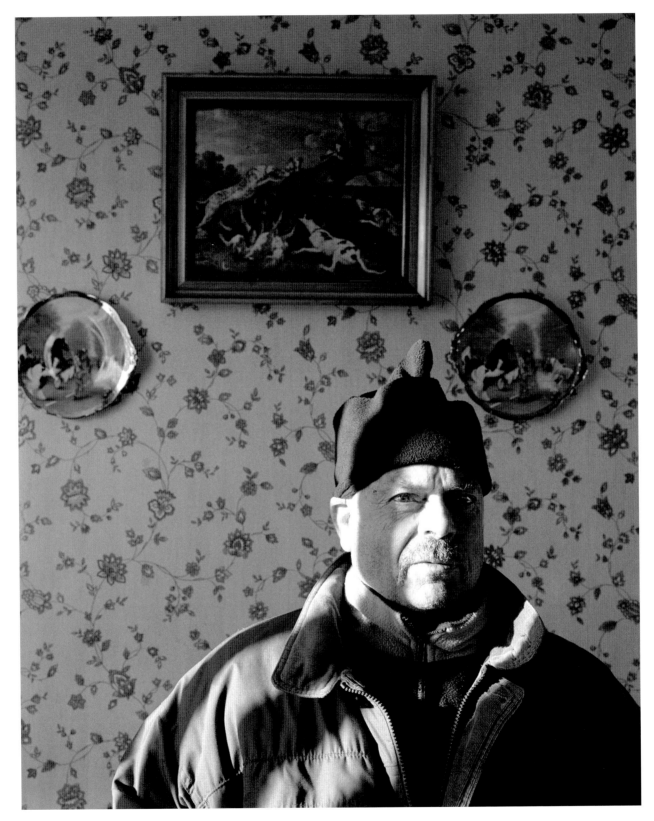

SERVICES

The veterinarian is probably the best informed person in the area. The hub. They come into contact with every sector of rural life, dealing with a horse with a hernia to a pet rabbit with the runs. Their finger is, literally, on the pulse of the countryside.

Nobody can do without the vet, but some can do without the farrier, but not if they own a horse, and an awful lot of people do own horses. They also need to be taught how to ride.

Being a farrier is physically demanding work; holding up a horses leg, bent backed, then hammering home the nails for the shoe. When I saw the amount of smoke the farrier inhaled from the application of a hot shoe to the hoof I thought it was a certain route to early lung cancer, but he assured me they were long lived and attributed the fact that he never got a cold to the medicinal qualities of the smoke.

Many people would rather pretend that slaughter houses did not exist. Sausages come in a packet. All that squealing and sharp knives slicing through carcasses for our convenience is uncomfortable. But the workers are professional people governed by strict standards of hygiene and humane behaviour and they are proud of their craft. When I was there photographing organic pigs being dispatched and dismembered, the Bee Gees' *Staying Alive* suddenly came on the radio they keep blaring in the shed.

I have included only a few of the myriad service sectors that keep the countryside running. Seasonal labour, mechanics, gamekeepers (who feature elsewhere), animal transport, union organisers and many more provide essential services necessary for the smooth operation of the countryside; for it is a business, not a natural idyll.

Farrier Wilf Barton shoeing a horse

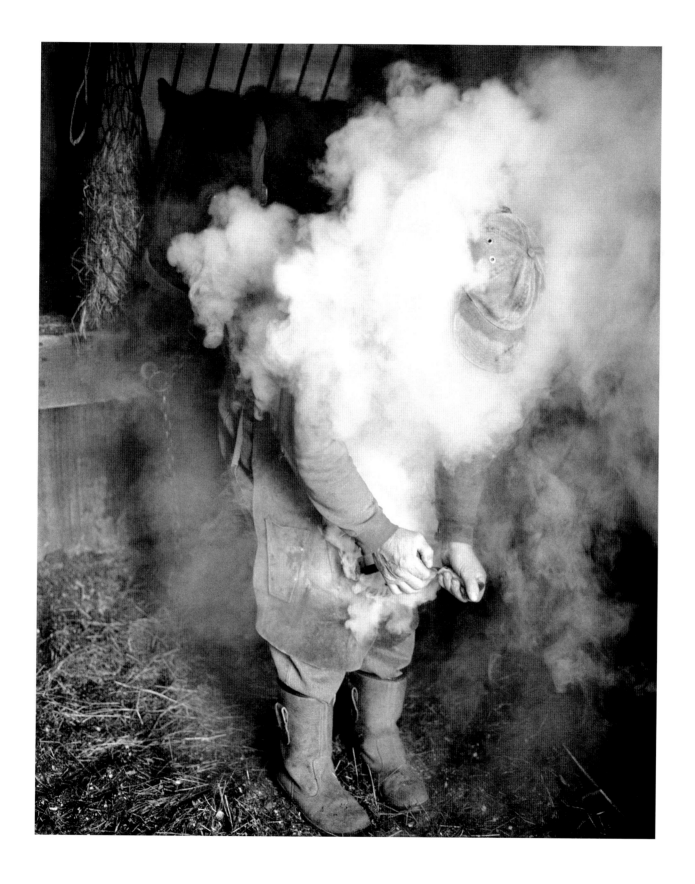

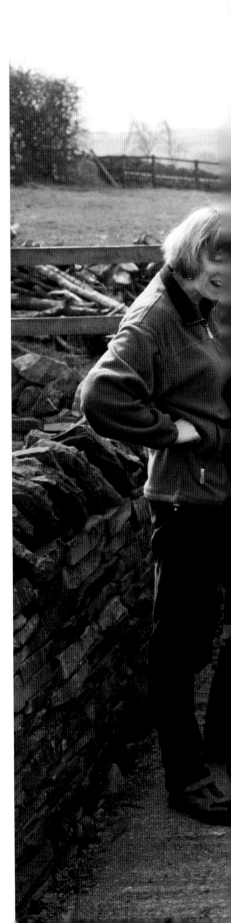

Farrier Wilf Barton oversees a horse being shoed

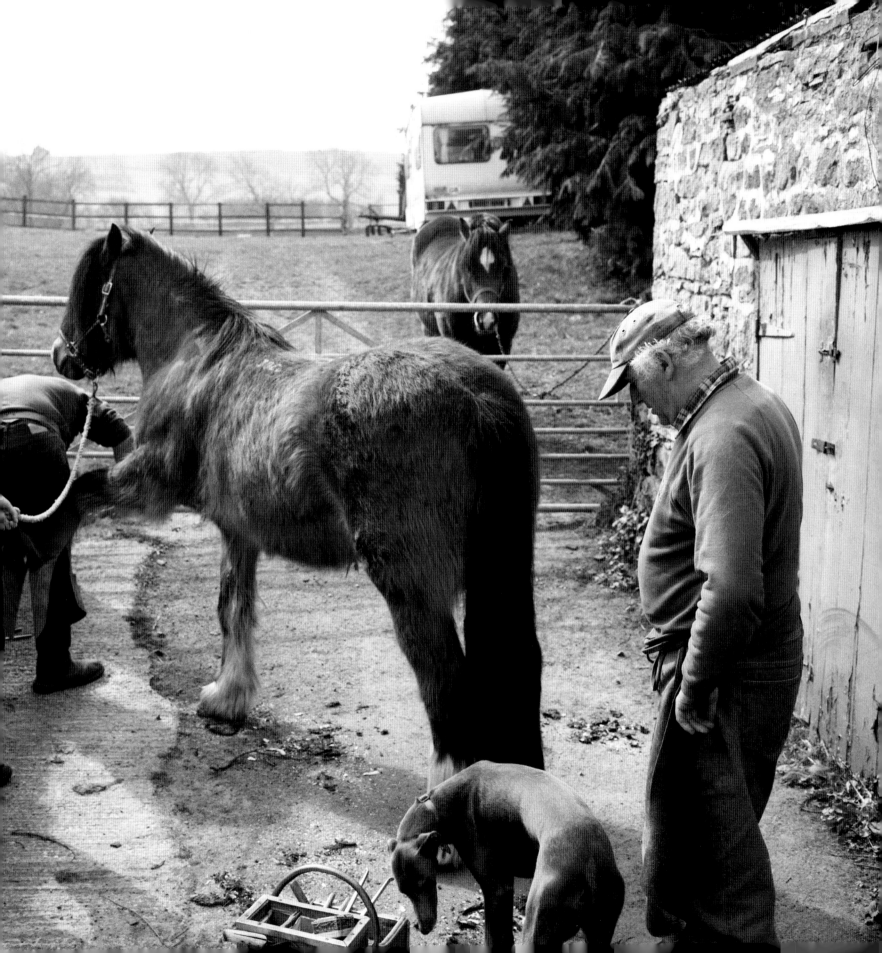

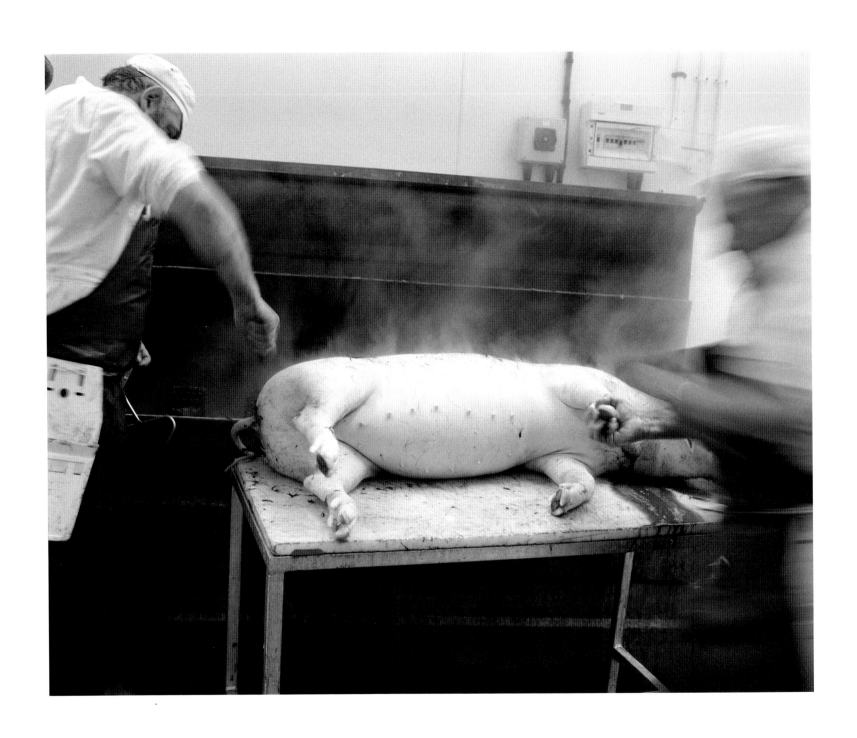

Removing pig's bristles after steaming at a slaughterhouse

Oakland Vet Centre, Yarm

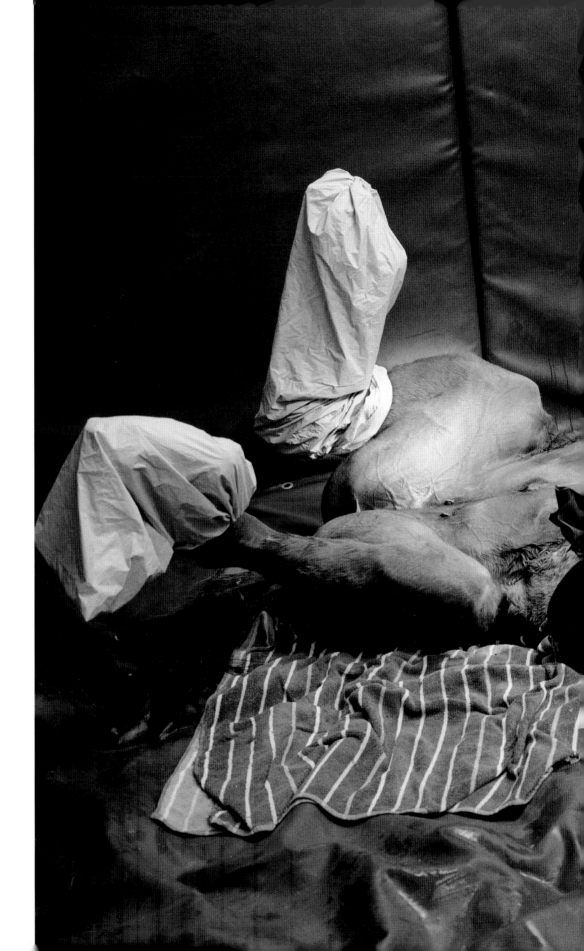

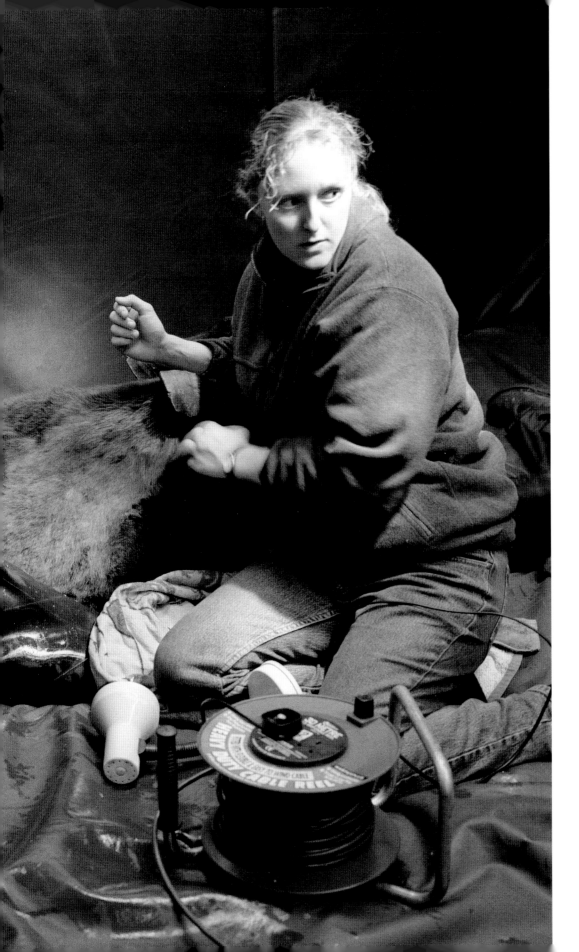

Oakland Vet Centre, Yarm. Hernia operation on a horse

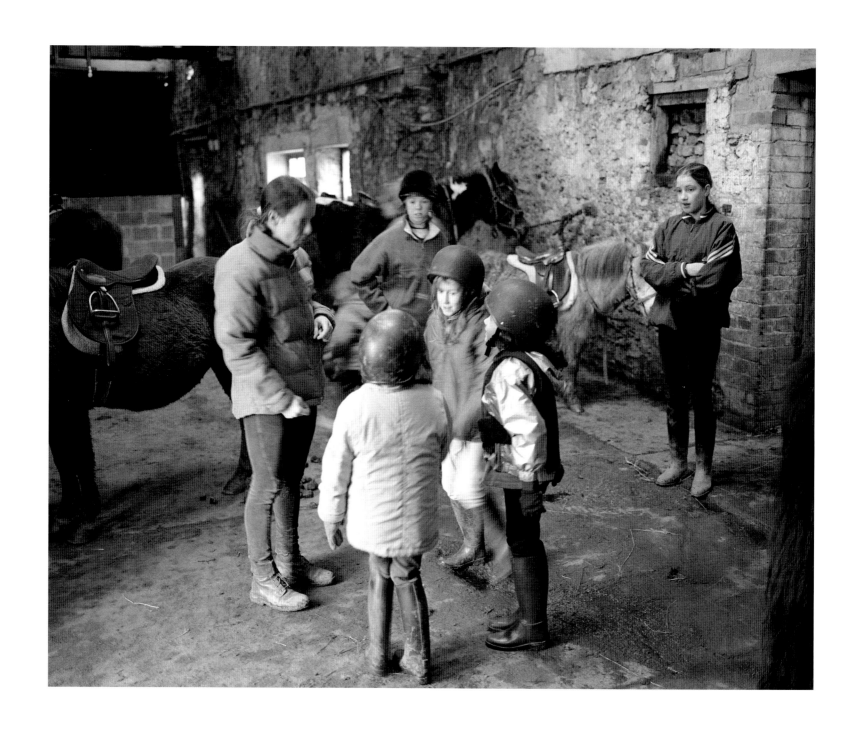

Above: Riding school
Right: Unborn piglets at a slaughterhouse

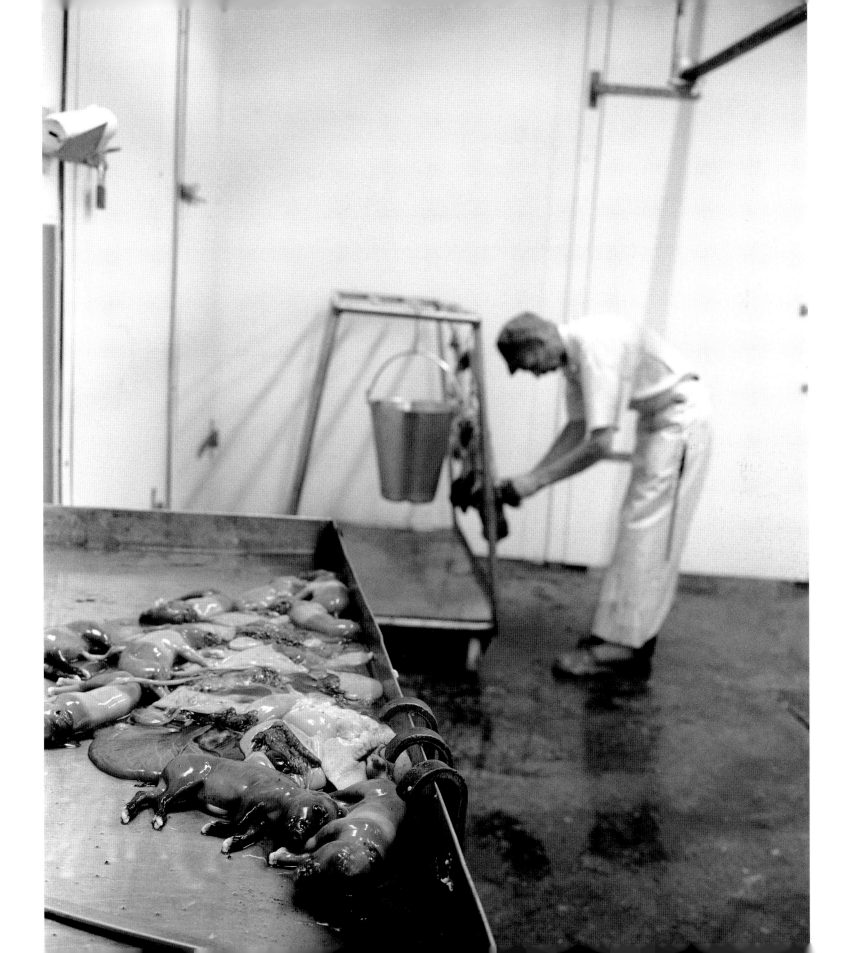

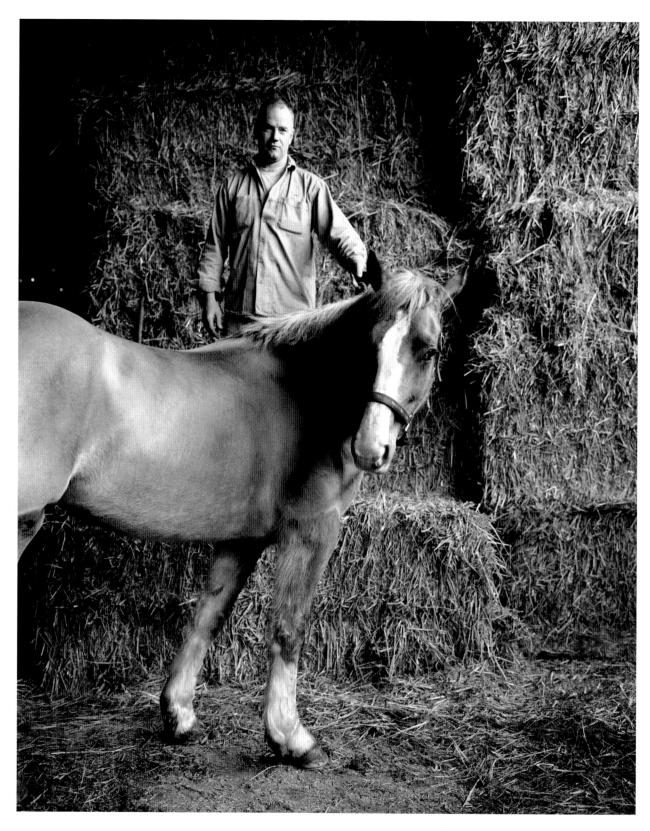

Farmer and owner of a riding school, Roger Vaux

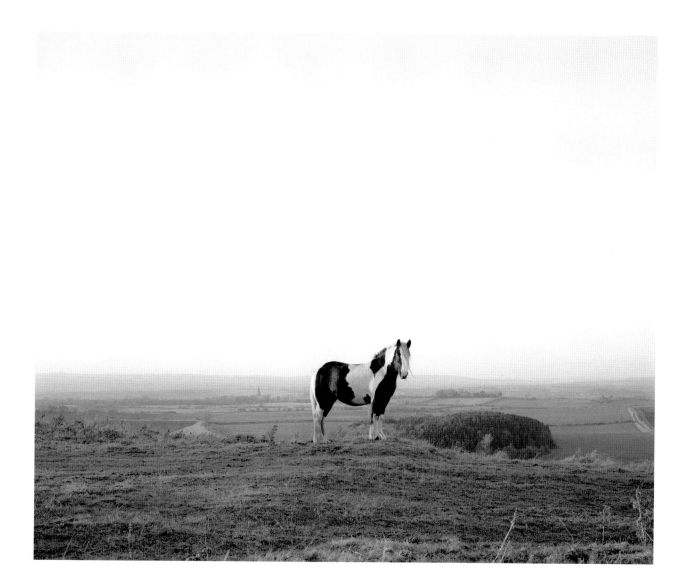

HUNTING WITH HOUNDS ON FOOT

Beagles hunt hares and it is done on foot as the terrain is generally too difficult for horses, and hares, unlike foxes, tend to stay within their area. When chased, they circle round about rather than running across country. Even if the terrain was suitable for horses, circling around is not the most interesting way of riding, but it does mean spectators can watch from a good vantage point without having to move far, once the hare has been sighted. The Master of the Hounds must keep with the circling pack and needs to be very fit.

I didn't know there was such a thing as a mink hunt until I started this work. Mink farming was introduced to England in 1929 and escapees soon began breeding in the wild. More recently, the problem has been exacerbated through the 'liberations' of animal rights activists. Mink are larger and stronger than most indigenous predators in the UK and have had a destructive effect. In some areas they have exterminated water voles. Mink hunting has little effect on numbers. Far more mink are shot or trapped, which remains legal.

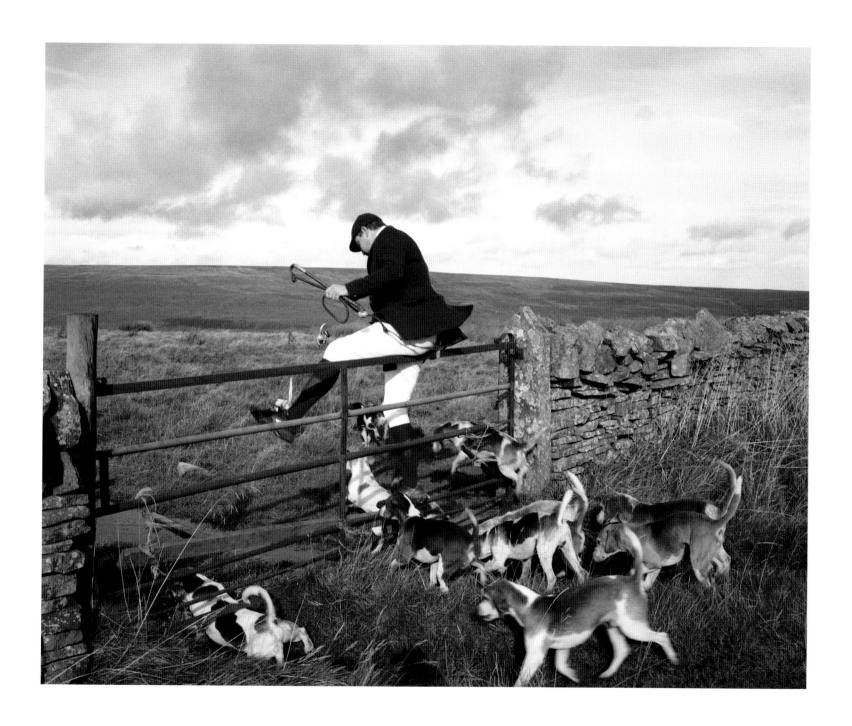

Hunting hare with Weardale and Tees Valley Beagles

Watching beagles

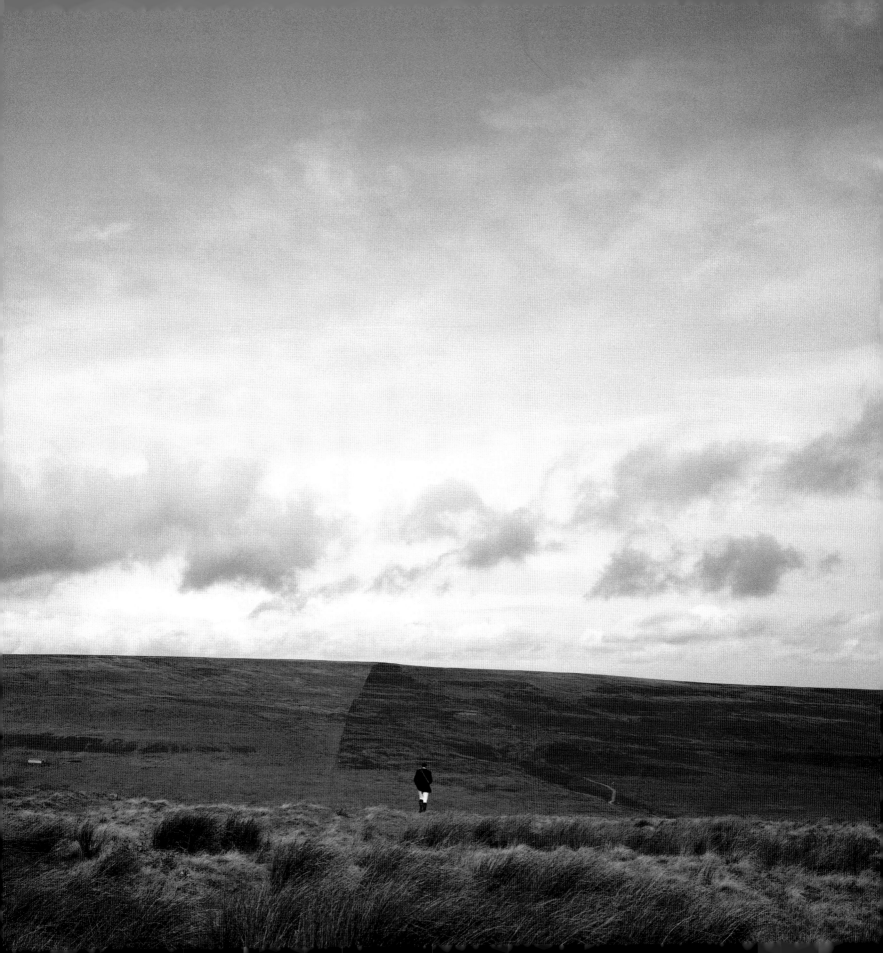

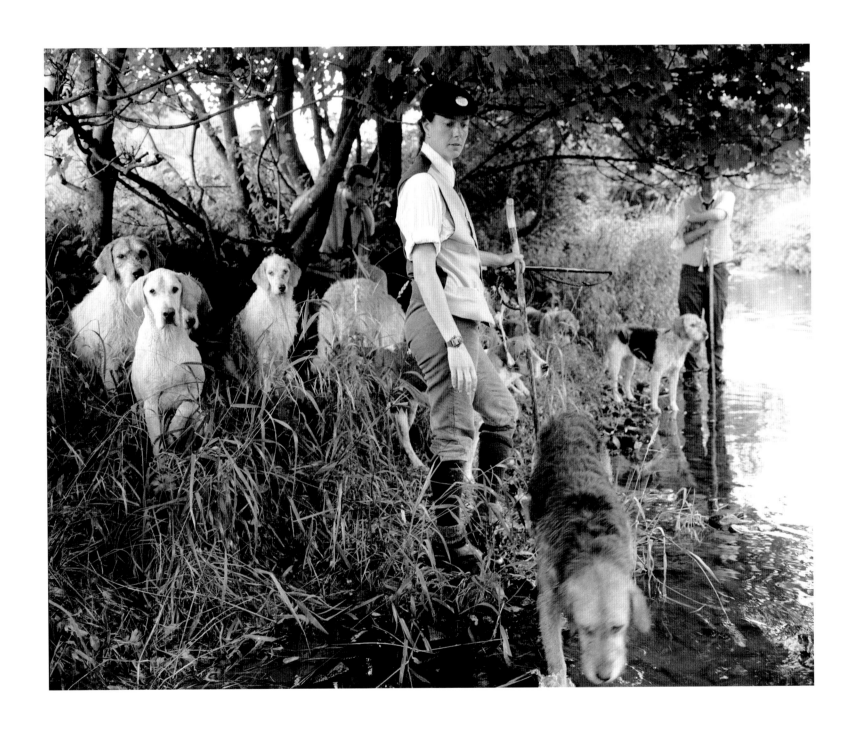

Hunting mink with Northern Counties Mink Hounds

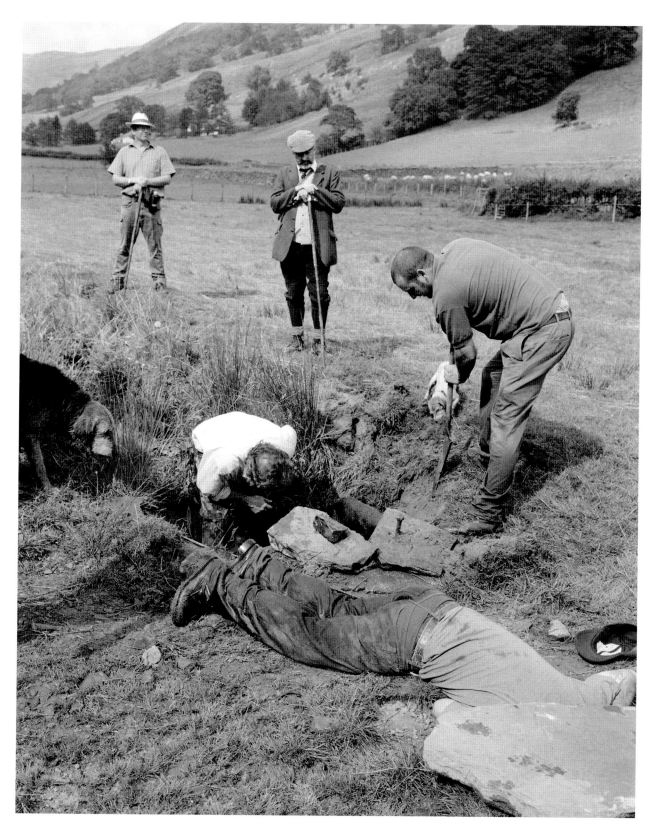

Hunting mink with Northern Counties Mink Hounds. Digging out mink

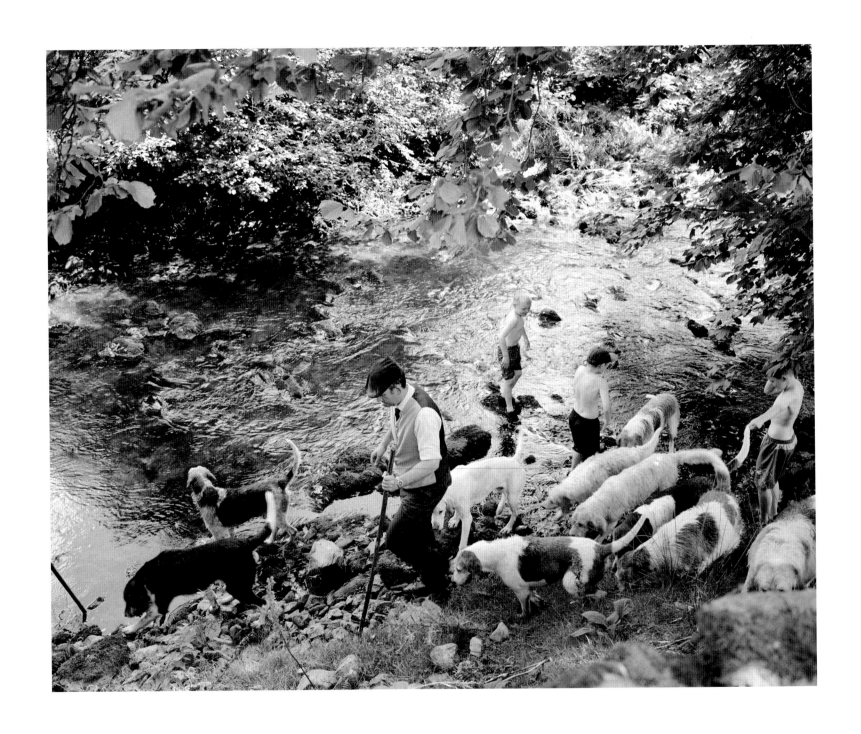

Hunting mink with Northern Counties Mink Hounds

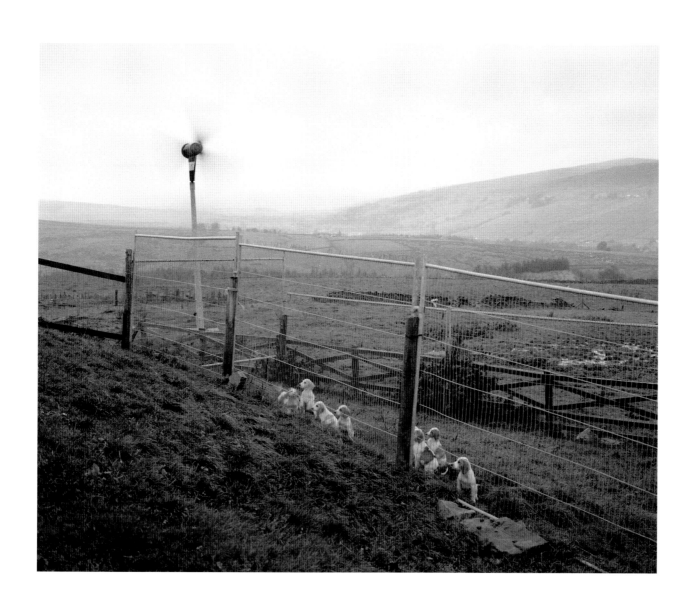

Beagle pups

POSTSCRIPT

It is easy to get sentimental about the countryside and drift into a post-romantic nostalgia about how simple, natural values are best, and how we seem to have lost them.

I hope nobody reads this book like that, although I have no questions of the book being a celebration of country life, but a realistic one, not sugar-coated with misplaced yearnings.

Climate change, population growth, new government legislation, technology, urban drift and environmental pollution are all absorbed by and change the substance of rural life.

Probably this generation of youth is less aware of and less interested in the countryside except as an occasional leisure facility than previous generations. Not surprisingly as most of them have been brought up in an urban environment. What were once small villages have evolved, as Horden has, into substantial towns. New commuter and weekend housing has been added. The rural is no longer an everyday reality. This is sad as they are missing out on a touchstone to human existence.

In the end the guardians of the countryside are those who live off it. It is they who know it best and understand that for all its damaged beauty it is what remains to us of Eden.

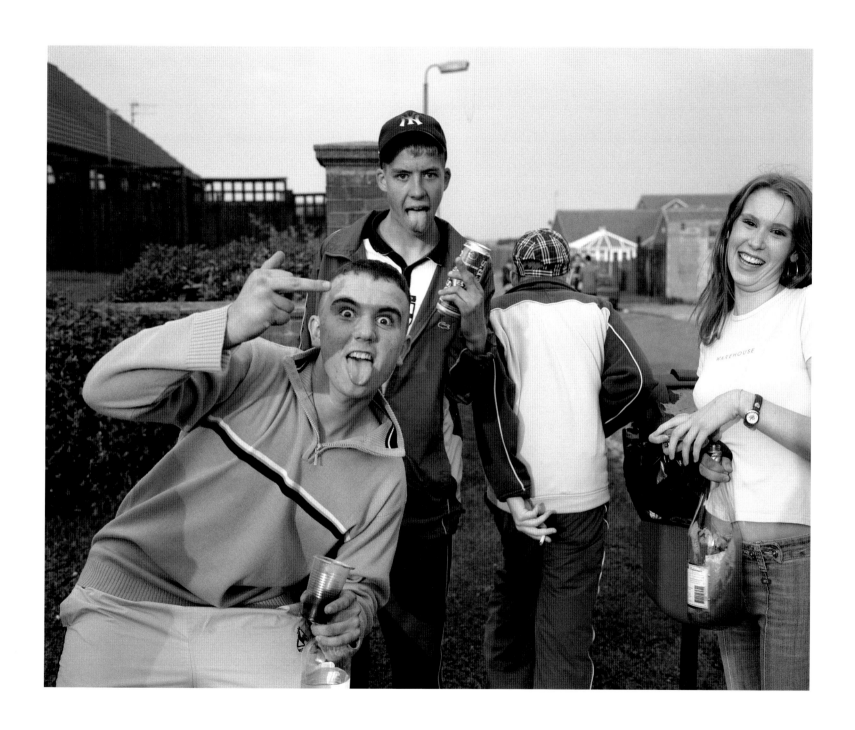

Youth on a drinking session in Horden

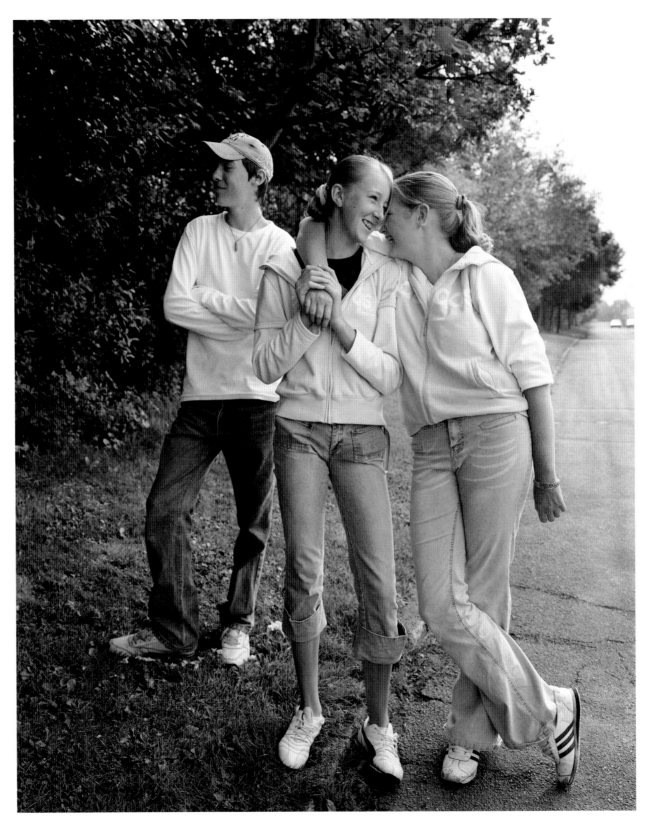

Youth on a Sunday afternoon in Horden

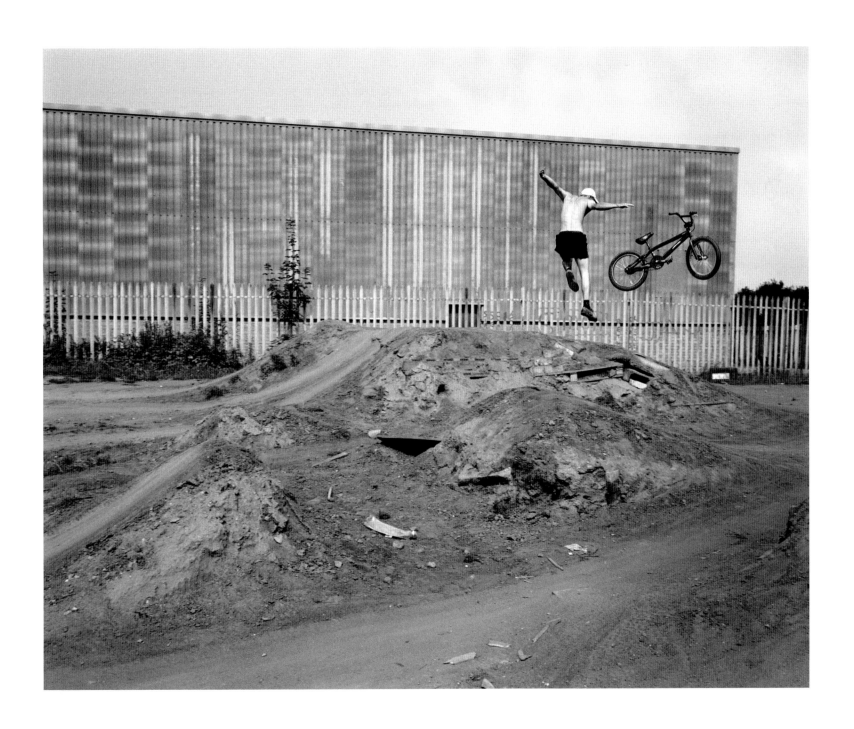

Improvised cycle track in Horden

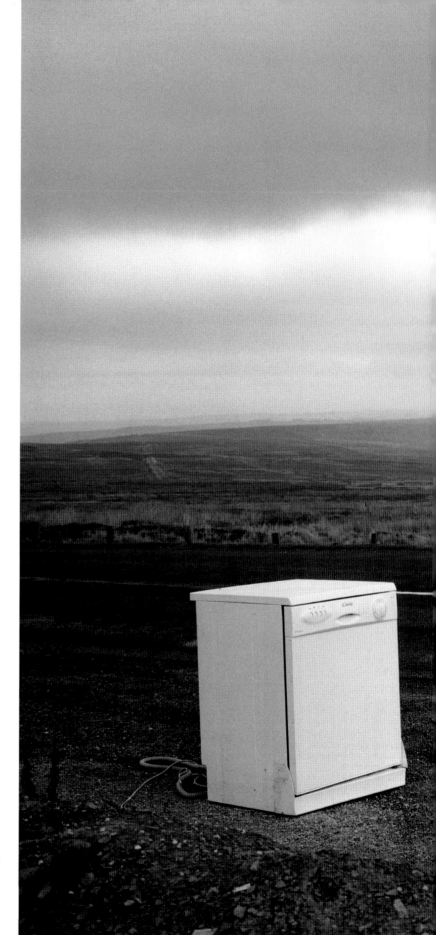

The jagged scrapyard of hawthorn,
A rush of wind in its hooks,
Berries ablaze like a lantern,
A robin among its roots:

The sons of ancient hedges
Bow to the east. Below,
Sky pools in the vallum.
The fields of the south glow,

Burnished copper. The north
Is verdigris and rust.
The wind harrows the silent
Lough. Violent, possessed,

Unpossessable country;
It stretches away
Into the distance, free-fall.
The rowan clings to the scree.

Neither England nor Scotland,
Itself alone:
Acres of secrets. Mouths
Stopped with a rubble of stones.

Extract from *This Far and No Further*, Katrina
Porteous

Dishwasher dumped on the Pennines

ACKNOWLEDGEMENTS

Thanks to Amber Side who kicked off this work and supported me
throughout and presented the first exhibition; in particular to Murray and Ellie
for their seemingly endless hospitality and support. Durham Arts who financed
me photographing Bowburn, Sara and Steve who also provided succour,
Magnum Photos in London who have done what Magnum should do,
Andrew at Northumbria University Press who took on this book, and
Mara at the Gallery who launched it.

 I will not try to name the many, many people who have, for no reward
to themselves, opened their lives, helped, suggested, encouraged or simply
let me get on with it, in order to make this work. To them I owe a debt
of gratitude.

 And then there are my sons, Cedric and Cameron, from whom
I have been absent to do this work, and my wife Miyako who has put
up with me all this time.